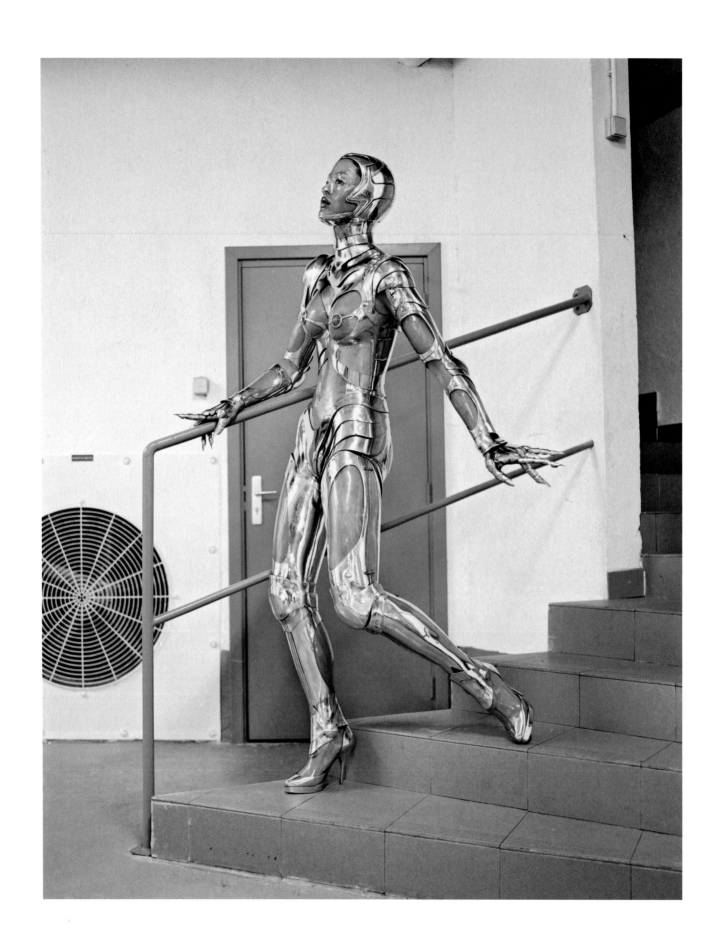

HELMUT NEWTON, *Machine Age*, November 1995,
© 2009 The Helmut Newton Estate/Maconochie Photography.

EXTREME BEAUTY IN VOGUE

SKIRA

FOREWORD

hat exactly is beauty, so endlessly pursued in recent years? To answer this question, we asked American *Vogue* to choose the most powerful pictures taken by its greatest photographers over the last eight decades. The works, symbols of the courage of those who have dared to push limits and defy convention, have been brought together in an extraordinary and unique exhibition, "Extreme Beauty in Vogue." The title itself conveys the sensational impact of photographs that are stamped in the collective imagination and have become the visual references of an era. Sensual, challenging, and audacious, the prints selected mirror our own creativity. We have been inspired by them and continue to look at them. Equally, we helped to create them with our world of beauty, femininity, and seduction.

Full lips painted red, a provocative gaze framed by long lashes, and brightly polished nails—makeup is the external image of a person's psyche and manner, as well as a reflection of the dreams and desires, the fears and forbidden longings of our time.

The pictures by Richard Avedon, Helmut Newton, Irving Penn, and the other great photographers featured in the exhibition have become perfect icons because they stretched the boundaries of beauty by ignoring all the rules—just like our visions that throw out the established canons of tradition and come to symbolize "Extreme Beauty."

—Domenico Dolce and Stefano Gabbana

IRVING PENN, *Chanel Couture Feather Headdress*, December 1994.

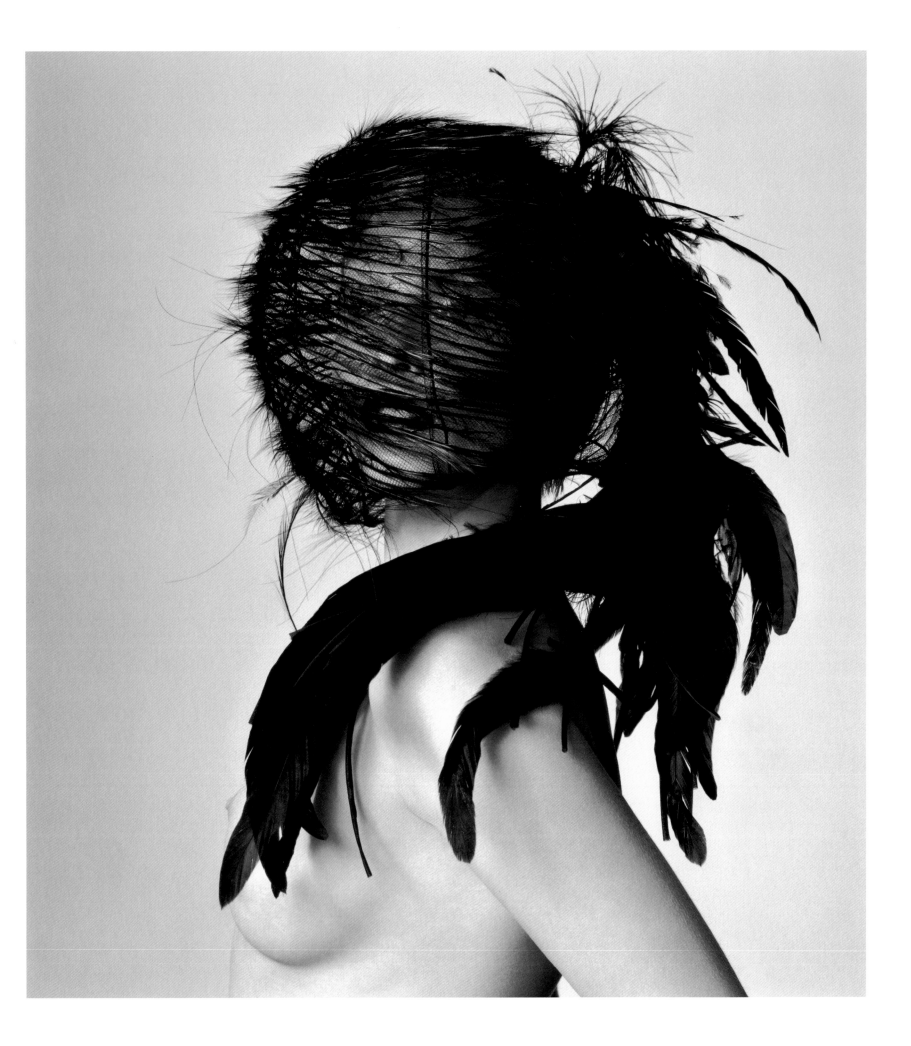

*t*he idea of creating an exhibition and a book of beauty photographs from *Vogue* set in motion an intriguing search for the essence of beauty journalism in *Vogue*'s history.

Phyllis Posnick, *Vogue*'s Executive Fashion Editor, whose work includes conceiving the beauty-related photographs in the magazine, combed the archives for the most memorable images of the past eight decades. What began to emerge was a rich vein that ran through the issues from the earliest days of beauty photography to the present: a fearless edge to imagery in the context of beauty, health, and fitness. A succession of visually bold editors in chief and a tradition of collaborating with the best photographers resulted in a collective *Vogue* eye: one where prettiness is less important than a radical vision of physical aspiration, where wit is provocative, and where a shocking image is more arresting than a safe photograph.

So here is the best of *Vogue* beauty, in all its extremity.

—The VOGUE Editors

PARADOX AND PROVOCATION

By Eva Respini

*i*n 2001 *Vogue* published an article about the cosmetics industry, reporting that since 1971, cosmetics companies had waged what became known as "the Mascara Wars" in the search to develop the ultimate mascara. Legendary photographer Irving Penn made the arresting picture that accompanied the article. Two wands vied to apply mascara to the lashes of a bloodshot eye set in a Kabuki-white painted face. The model's eye was supposed to be closed for the photograph, but real life intervened. It fluttered open at the end of the session, irritated from countless applications of mascara, and Penn immediately instructed the model to freeze so he could shoot a few more frames. Every blood vessel—like a delicate root or a tiny tributary—is captured in exquisite and sharp detail. To anyone who has applied eye makeup, worn contact lenses, or seen *A Clockwork Orange,* this picture triggers a physical reaction—a shudder or perhaps an involuntary grimace. The fruit of luck and gut instinct, as well as consummate professional skill, Penn's photograph celebrates imperfection in a time of airbrushed perfection. It is an exercise in the beautifully grotesque.

Rewind two millennia. In the declining years of the Roman Empire, during the despotism and decadence of Nero's reign, the emperor began to rebuild his palace after the great fire that devastated Rome in 64 A.D. By the end of that decade, Nero had committed suicide, and the heavily ornamented building, a symbol of the empire's excesses, was filled with earth and built over. When

the palace's cavelike ruins were uncovered during the Renaissance, wall paintings of strange hybrid animal, plant, and human forms were seen for the first time since antiquity. Their revelation was electrifying. The term *grotesque* (derived from the same Latin root as *grotto*) was coined to describe these ancient decorations, and the grotesque tradition in art and literature has captivated artists ever since. The grotesque, which differs from its colloquial usage, can take on a number of guises—crude, vulgar, and monstrous, but also whimsical, fanciful, and humorous. With its combination of disparate parts, it is the embodiment of paradox and contradiction.

Bodily mutilations are regularly broadcast into our living rooms via video games, horror movies, TV crime shows, and terrorist beheadings on the Internet. Indeed, the grotesque is alive and well in our contemporary culture, and the pictures in *Extreme Beauty in Vogue* reflect our continued fascination with it. Bee-stung lips, bodies crawling with serpents or spiders, heads covered with beads, feathers, and burlap. Women corseted, masked, bound, and teetering on high heels. Bodies measured, bandaged, prodded, and poked. Women screaming, smiling, kicking, and fighting while sporting swimsuits, hats, jewelry, or nothing at all. But there is beauty here, too. The models are the epitome of physical perfection, and the photographs are the best of *Vogue*. It would be more accurate to suggest, rather, that these grotesque fantasies and illusions propose new hybrids of beauty for an age in which the pursuit of beauty has become an extreme sport.

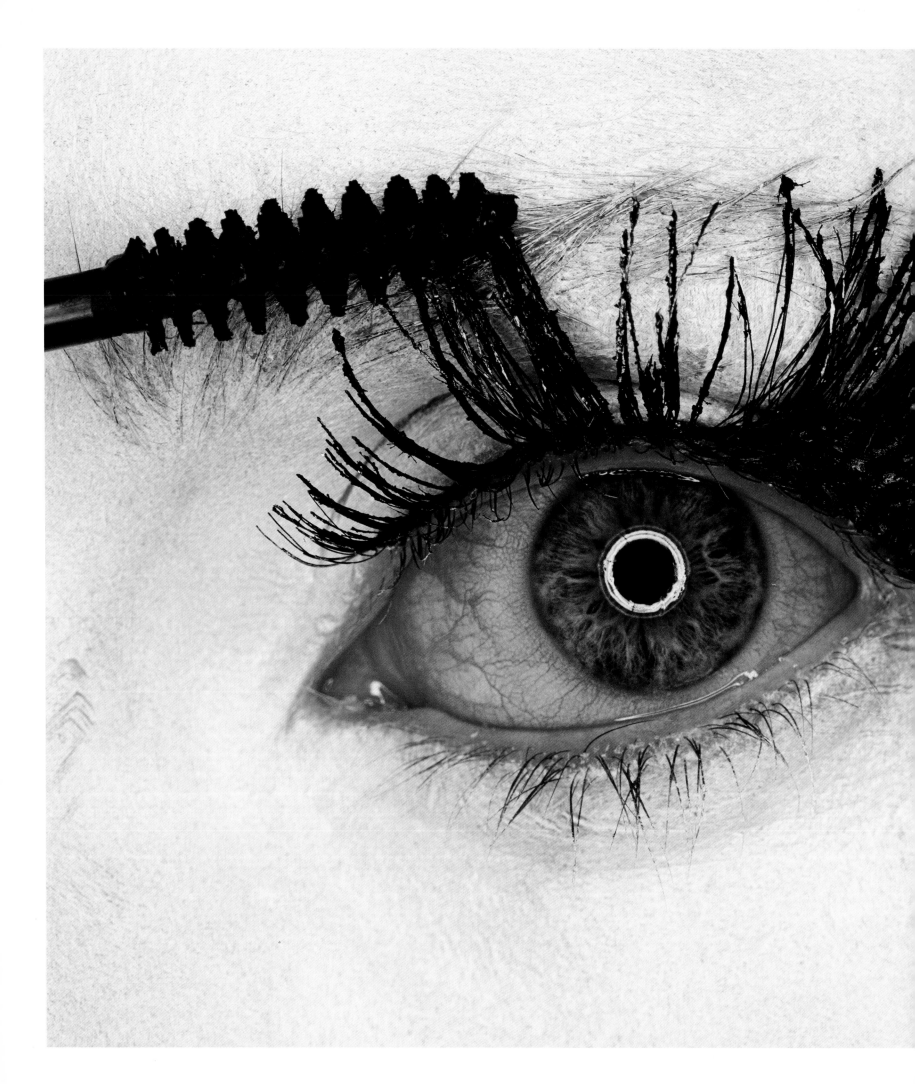

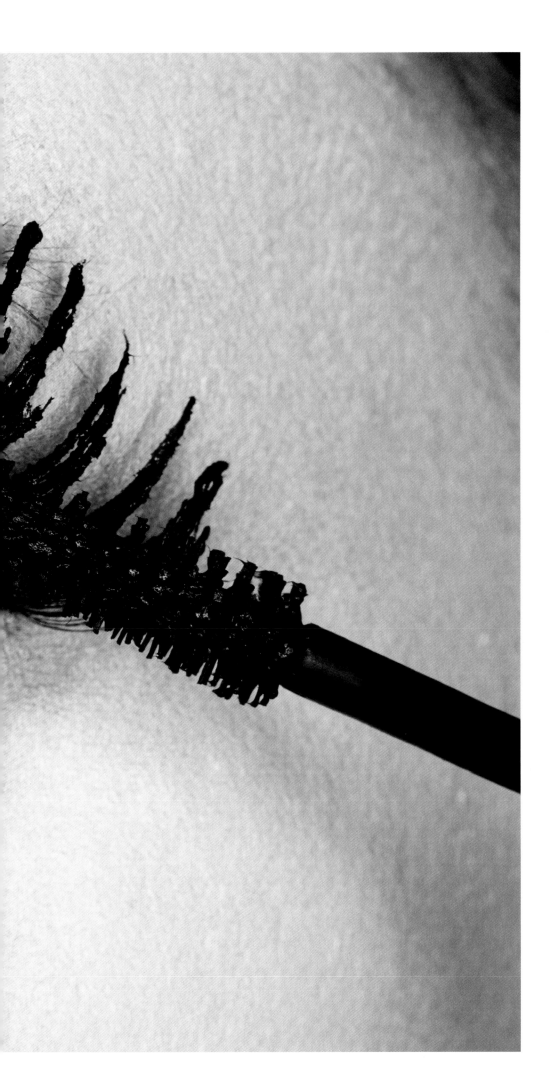

IRVING PENN, *Mascara Wars*, July 2001.

Gathered here are photographs created to accompany articles about health and beauty that extolled must-have creams, the latest fitness crazes, new at-home facials, and advanced technology to plump lips, reduce signs of aging, or reveal shapely lifted knees. The articles also cautioned against sun damage, overexposure to the elements, and the extremes of the beauty industry. However, these photographs are not merely didactic counterparts to the texts; they are anti-illustration illustrations. They inspire, provoke, and challenge us to think about the nature of beauty itself.

This book and exhibition provide access to some of the most memorable *Vogue* moments. The giants of fashion are represented in extraordinary photographs and iconic beauties from *Vogue*'s last 80 years. From its inception, in 1892, as one of the first illustrated fashion magazines, *Vogue* has been the supreme arbiter of glamour and taste. In these pictures we witness the shifts in what was considered the ideal woman's body. Since *Vogue*'s infancy, when elegant and refined socialites graced the magazine's pages, her figure has morphed alongside each era's standards. She flaunted a slimmer silhouette as a flapper; in the next generation her strong, athletic limbs jumped off the page; she was androgynous, wide-eyed, and childlike in the swinging sixties; 20 years later she grew into a fit Amazon; and in recent decades she has seemed painfully thin. The ideal woman has become skinnier, younger, increasingly airbrushed and Photoshopped. In 1979, *Vogue*'s renowned art director Alexander Liberman commented on this shift: "The thinner, the less 'feminine' the model's body," he wrote, "the more she could act out a graphic grotesque of limbs incredibly quartered in space."

Fashion has always been about the body. Clothes are worn and activated by bodies, after all, and the quest for the "clothes hanger" silhouette is the preoccupation of the fashion and beauty industries. It is no accident that the bulk of the photographs in *Extreme Beauty* celebrate the figure, from the strong and shapely women who dominate Helmut Newton's photographs to the lithe models lounging in a bathhouse photographed by Deborah Turbeville, to the superwoman lifting a car by Steven Klein. The feminine form comes in all shapes and sizes, seen in the sumptuous curves of a seated nude photographed by Irving Penn and in Annie Leibovitz's picture of bodybuilder Linda Wood-Hoyte's flexed muscles, amplified by the bulbous appendages of her Comme des Garçons dress.

ANNIE LEIBOVITZ, *Linda Wood-Hoyte*, March 1997.

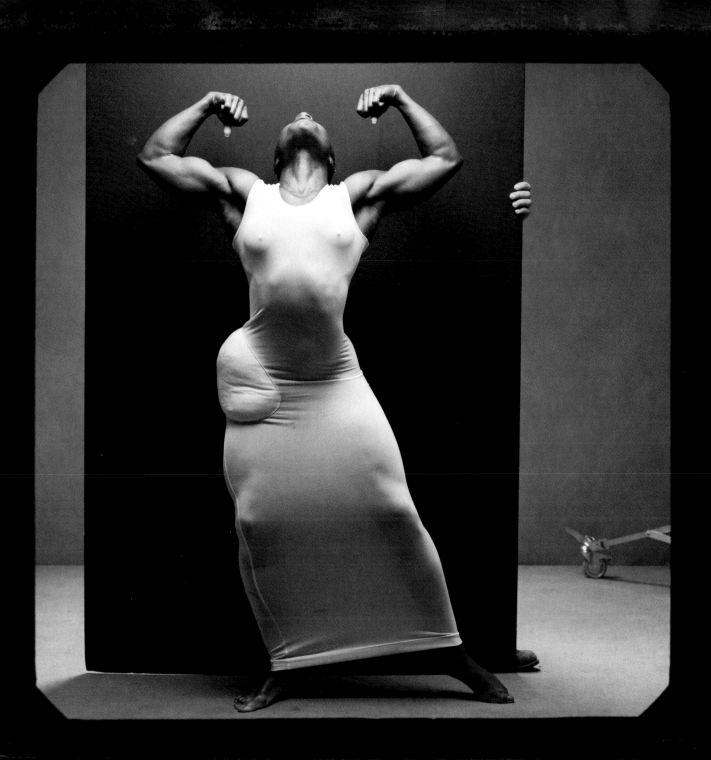

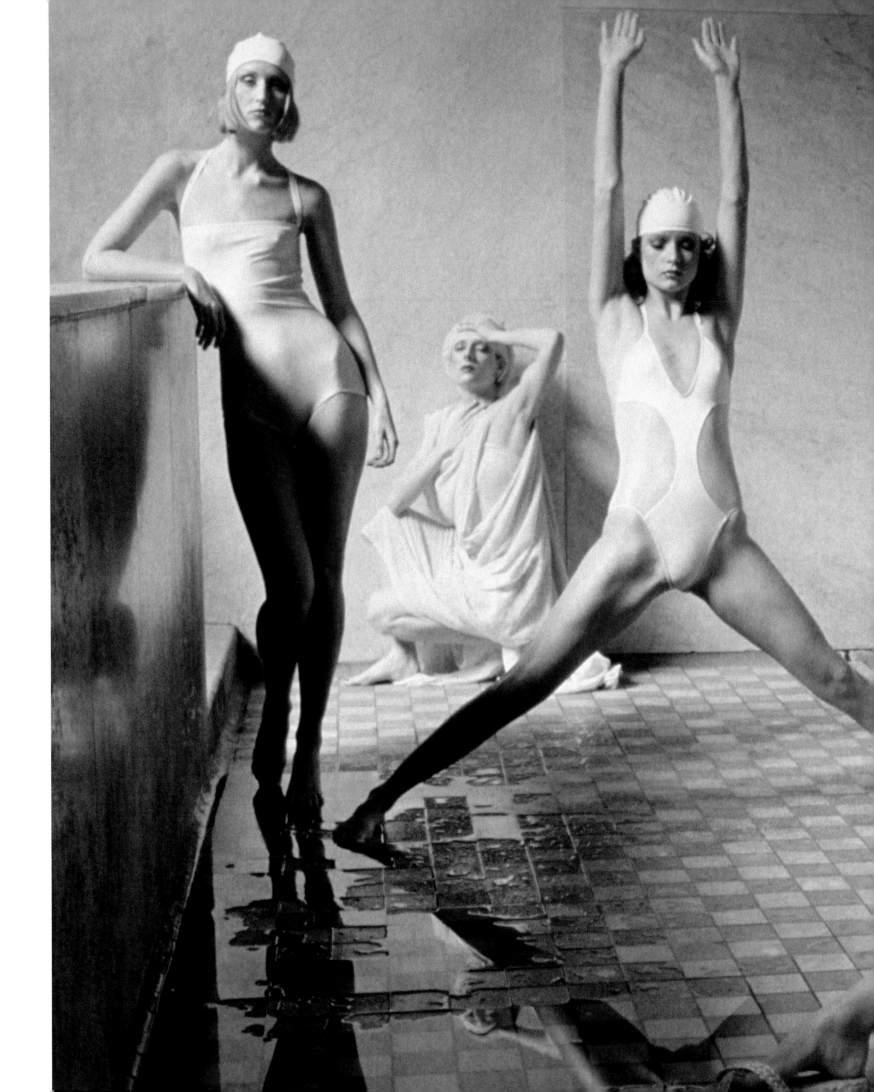

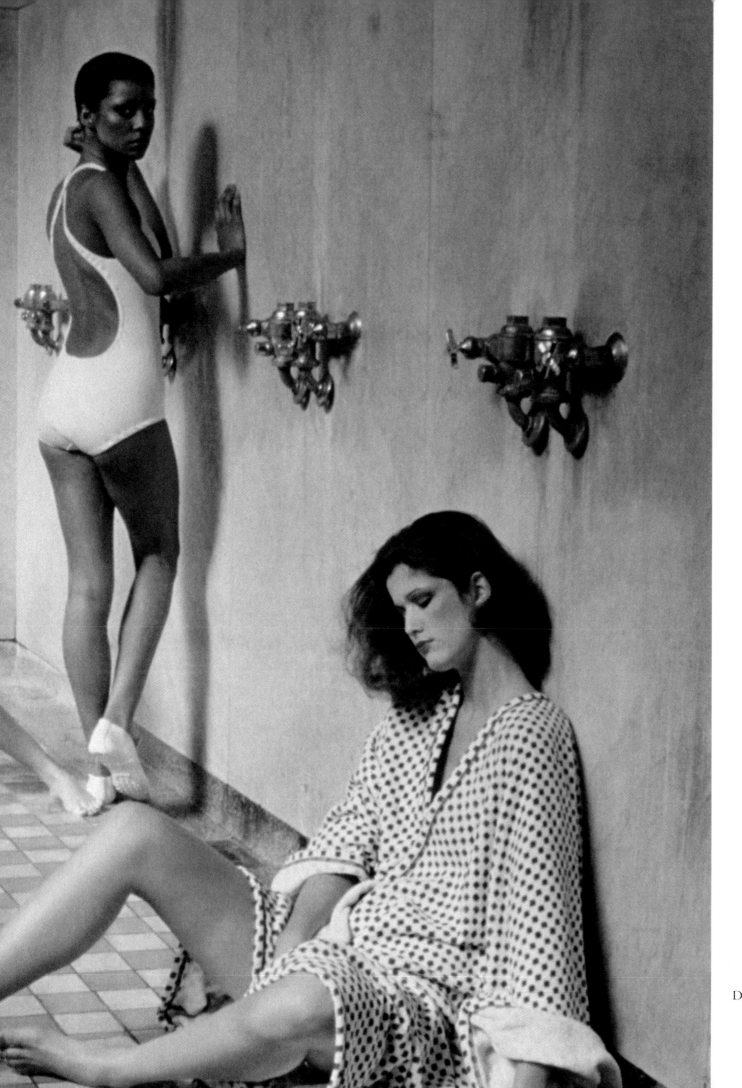

DEBORAH TURBEVILLE,
*Models in Public
Bathhouse in New York*,
May 1975.

The face—during the past decade, cosmetically manipulated more and more—is an equally rich site for the creative machinations of photographers and editors who conspire to make images that excite and provoke. "The feminine face needs leafage," the writer Colette, who herself hid behind her hair, used to say. The face is concealed by a metal mask in a Richard Avedon photograph and completely replaced by a bouquet of flowers in an image by Duane Michals. Irving Penn is particularly fond of transforming the face in his pictures. He has adorned it with a feather mask, covered it with hair, swathed it in canvas, doused it in milk, and bedecked it with delectable Fauchon candies. These embellishments transform a perfectly pretty visage into a canvas upon which the photographer can conjure even more beautiful and fantastical creatures.

Fashion photography is often accused of having nothing to do with the real world. These seductive fictions, populated with impossibly beautiful women and clothes, are calculated to entice consumers, not address politics, economics, or wars. However, fashion photography is a compelling mirror of its time. It reflects the moment in which it was made, and it has always been an excellent barometer of what's new. These pictures tell us not only how women looked in a certain era—their hem lengths, lipstick shades, and hairstyles—but, more important, how they wished to look, live, and act. Each age has a value system of what is desirable and beautiful but also, by default, of what is feared and taboo. The styles, mores, and worldview of an era are present in pictures created by an industry programmed to the eternal *now*.

So, what does it say about our times that the photographs in this book are extreme, aggressive, bordering on violent, and all made in the name of beauty? In the spirit of the contradictions of the grotesque, this volume is a celebration of beauty but also a revolt against its rules. These pictures externalize the internal turmoil wrought by our fast-paced culture of stress, ambition, and "having it all." If the surface of a woman's body is a reflection of her psychology, then these amalgamations of distorted faces and contorted bodies suggest ambivalence toward the unrelenting pursuit of perfection. Just as the strange motifs unearthed more than 500 years ago afforded us a glimpse into the life and imagination of ancient Rome on the eve of its fall, these photographs reflect the desires, dreams, and nightmares of our era.

RICHARD AVEDON, *Penelope Tree, mask by Ungaro, Paris studio*, January 1968,
© 2009 The Richard Avedon Foundation.

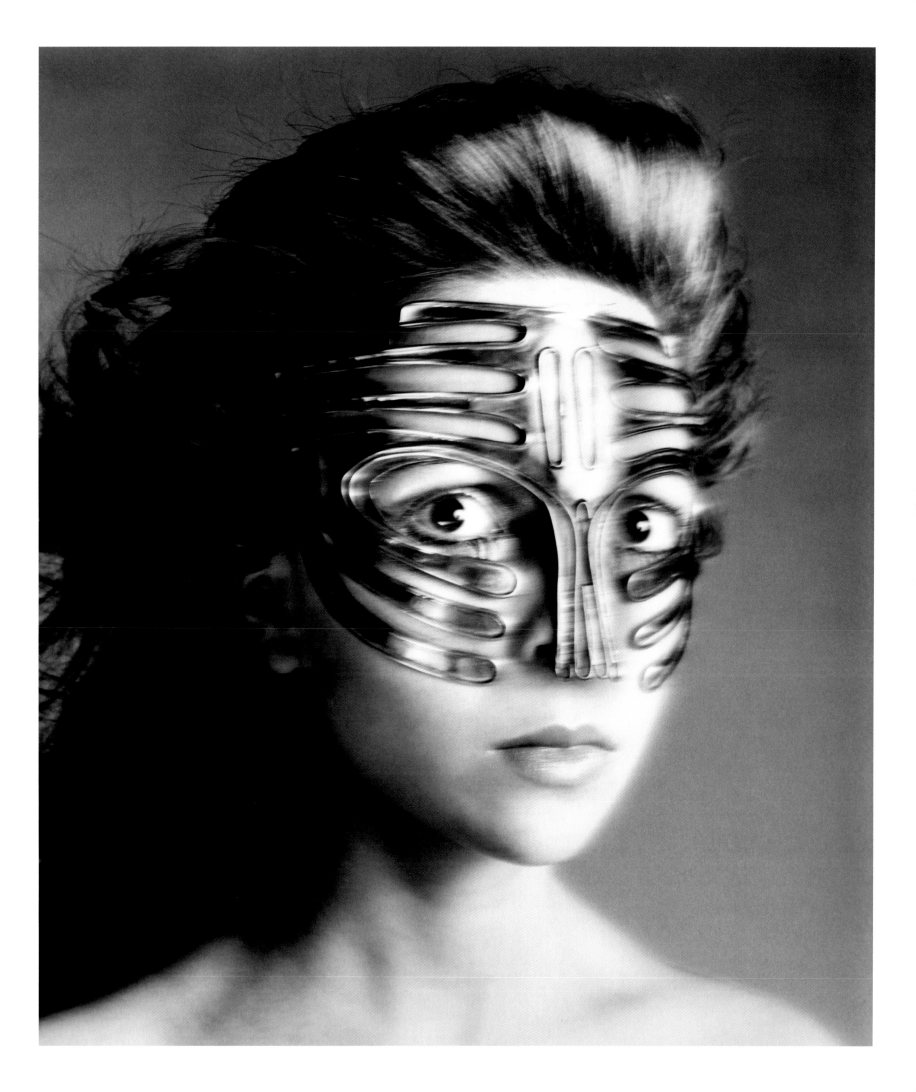

ICONS

ERWIN BLUMENFELD, *Jean Patchett*, January 1950.

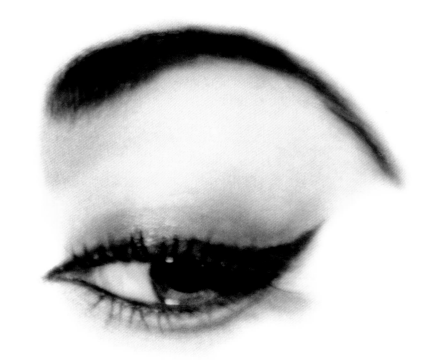

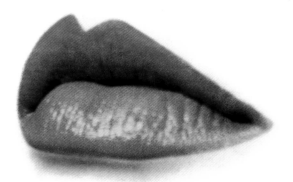

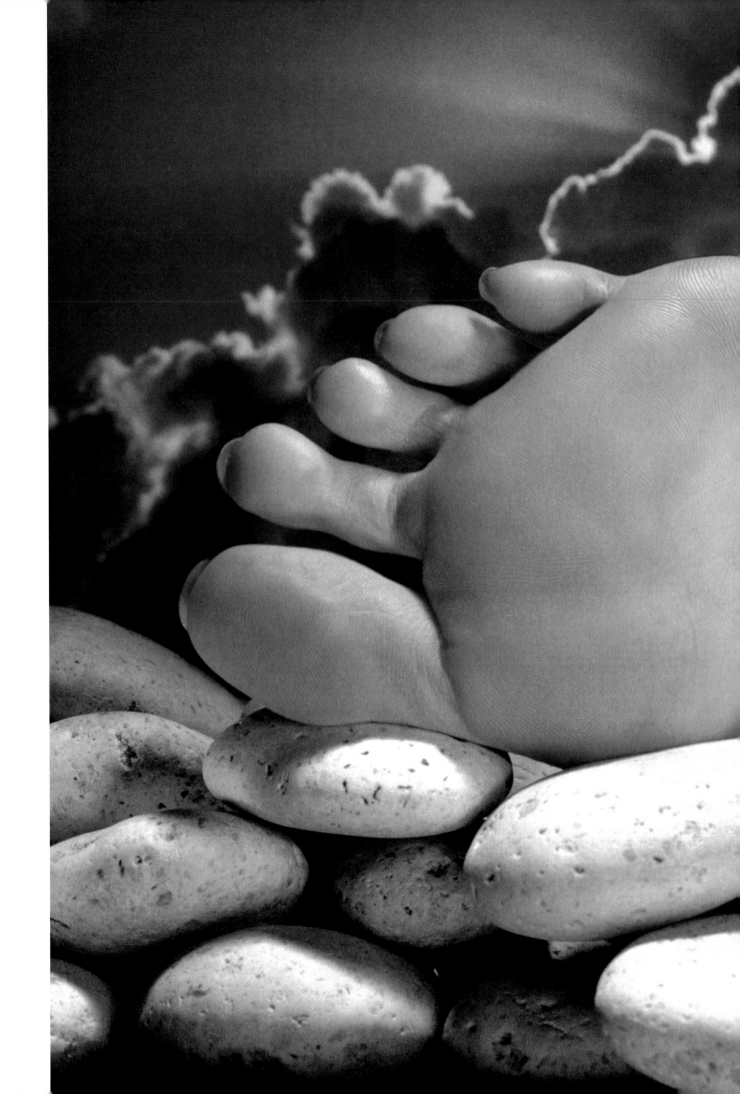

HIRO,
Foot, April 1982.

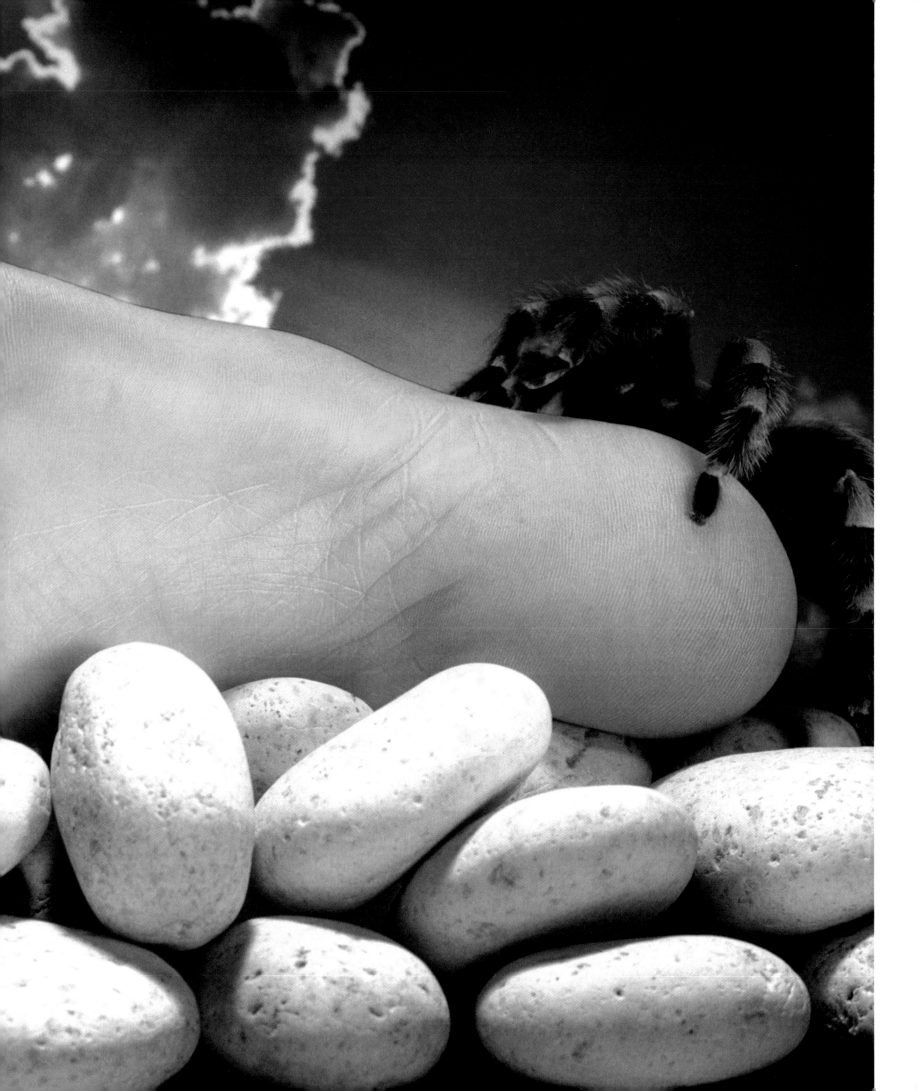

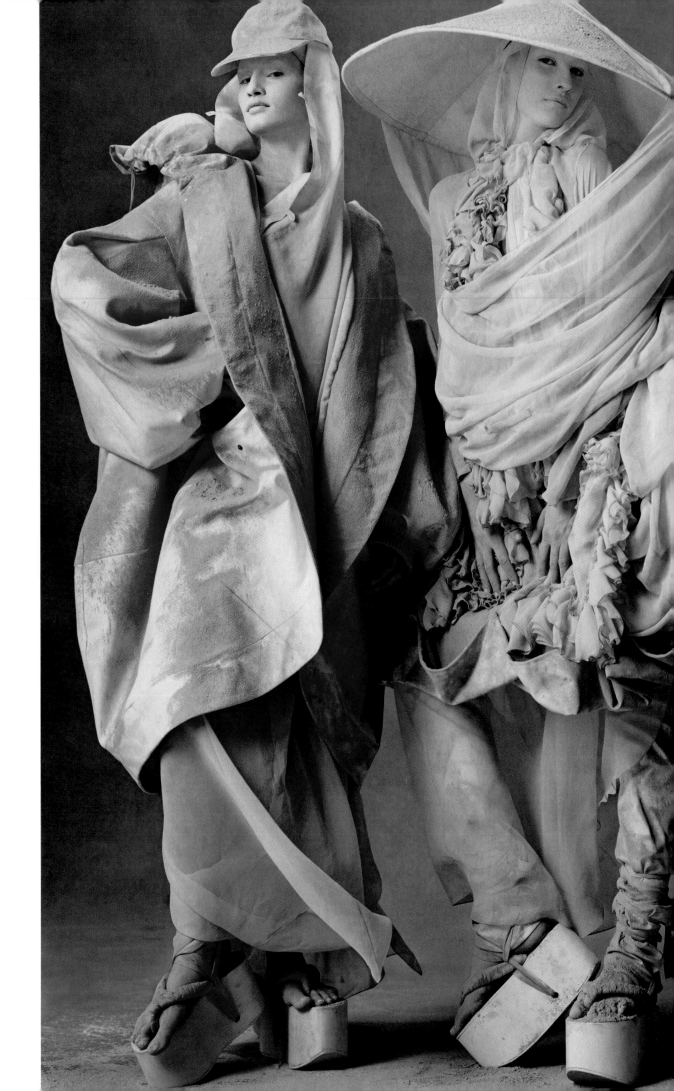

STEVEN MEISEL,
Untitled, John Galliano Models,
December 2002.

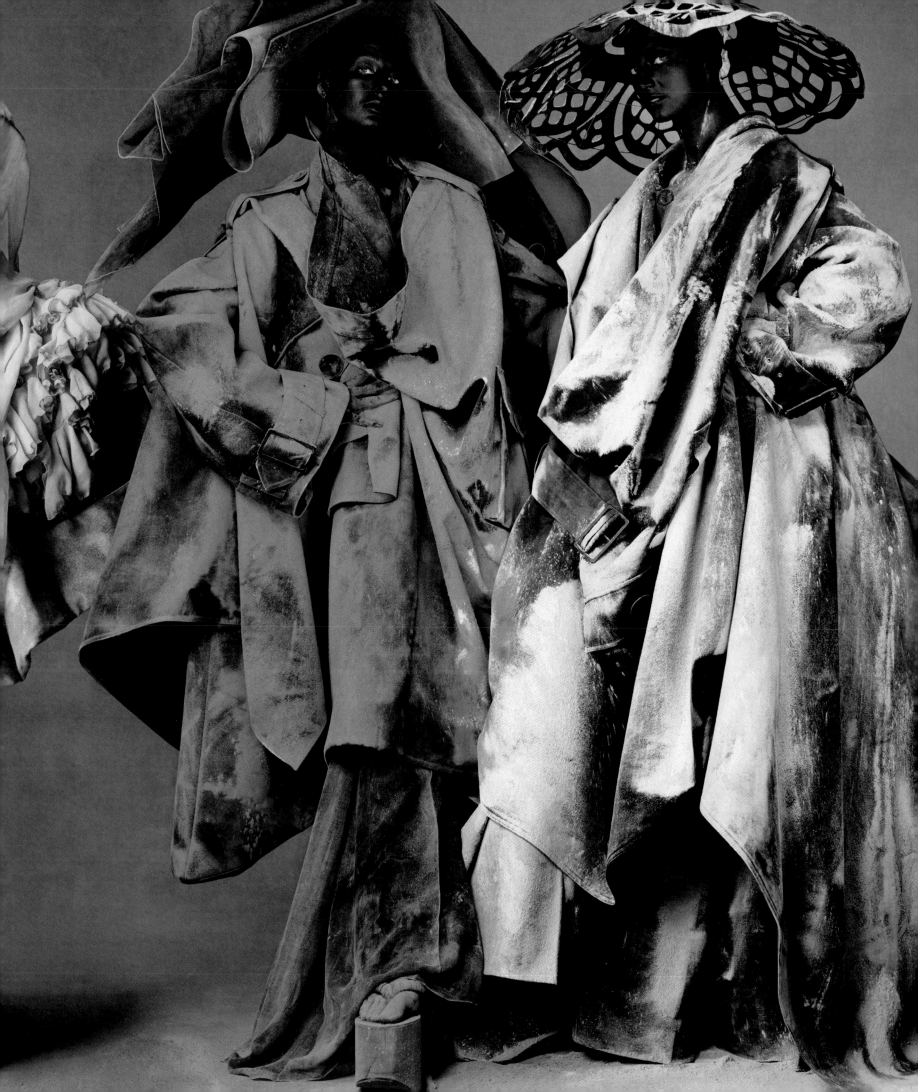

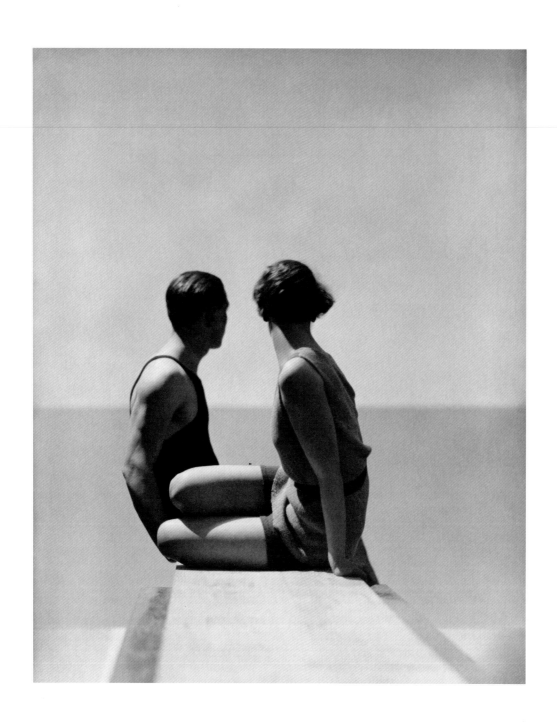

GEORGE HOYNINGEN-HUENE, *Modern Mariners*, July 1930.
RIGHT: CLIFFORD COFFIN, *Unknown Models*, June 1949.

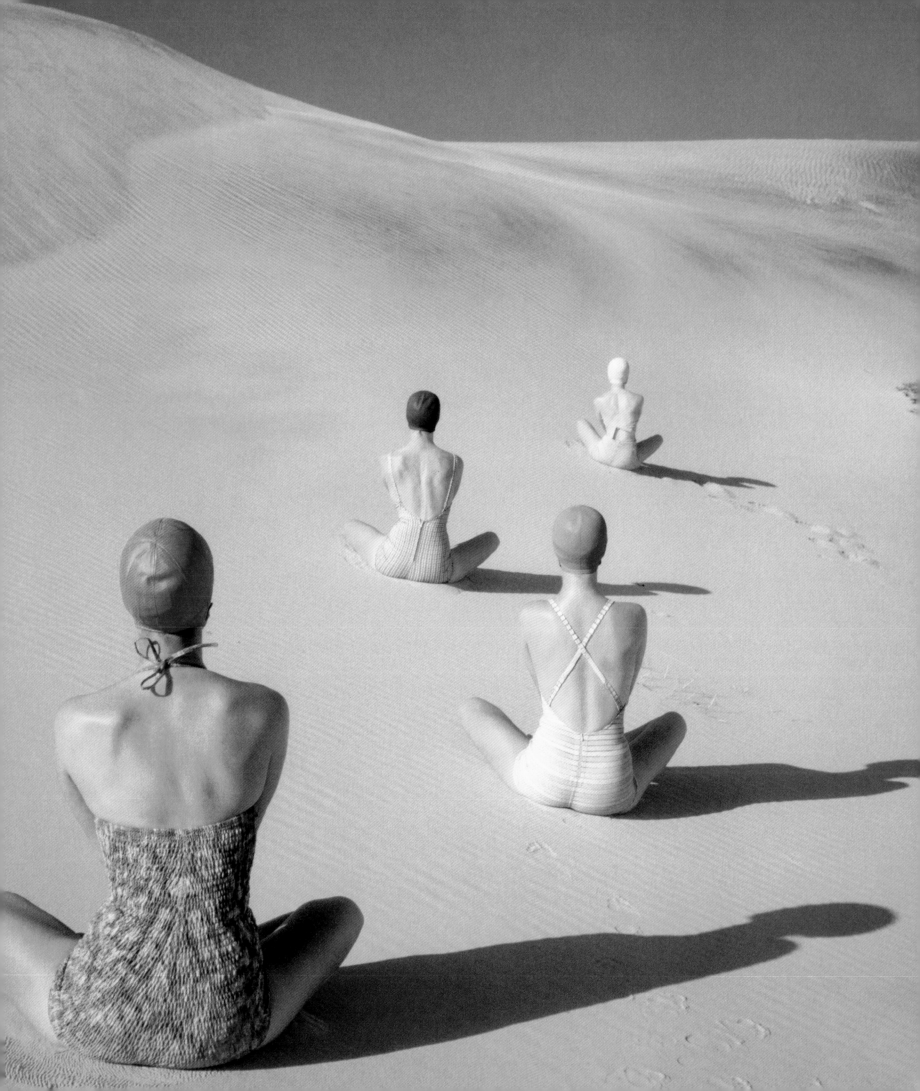

BRUCE WEBER, *Mike Tyson, Naomi Campbell, and Don King, Atlantic City*, December 1989.

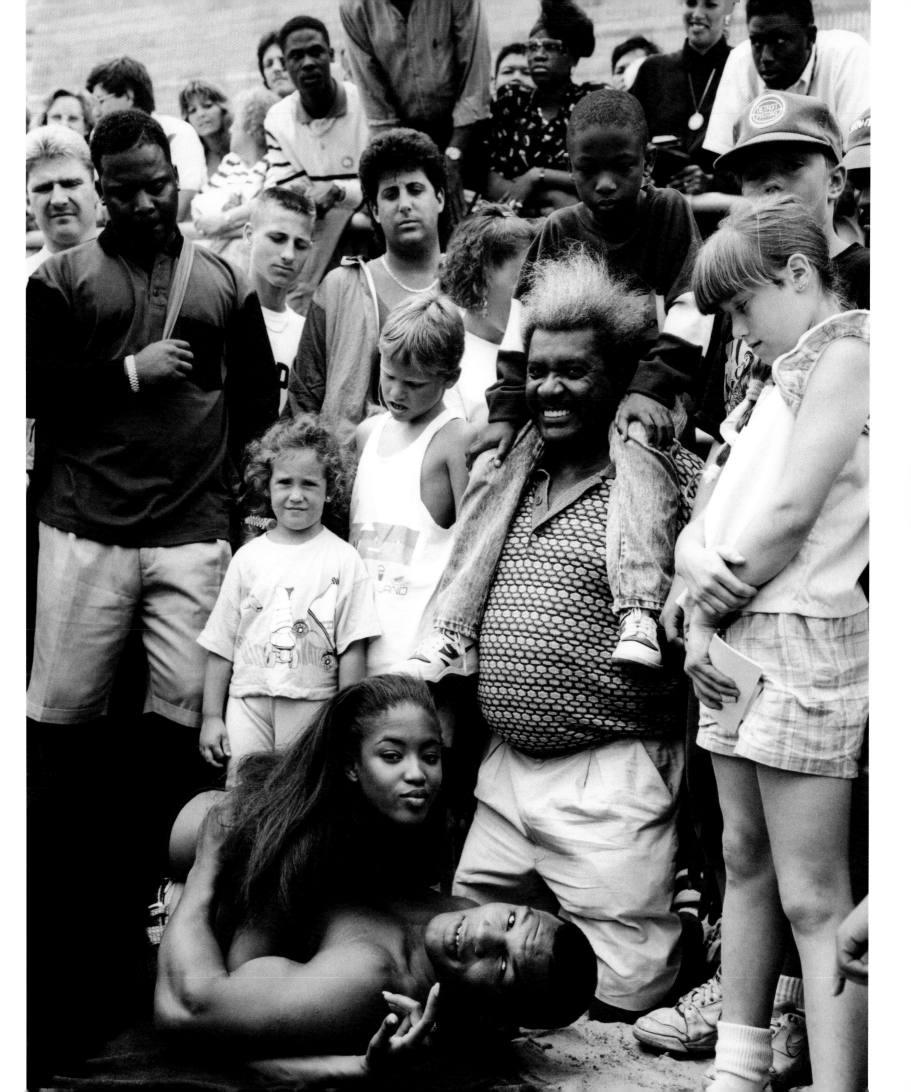

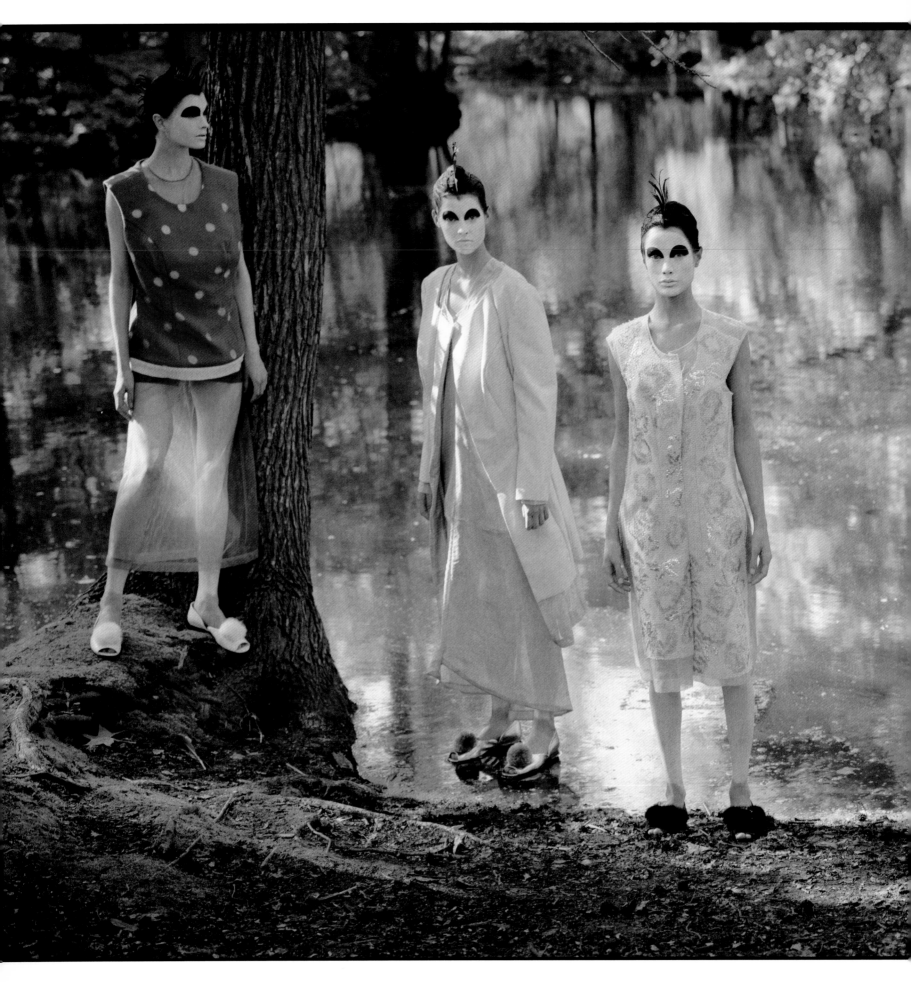

ANNIE LEIBOVITZ, *Comme des Garçons, Old Westbury Gardens, New York*, September 1997.

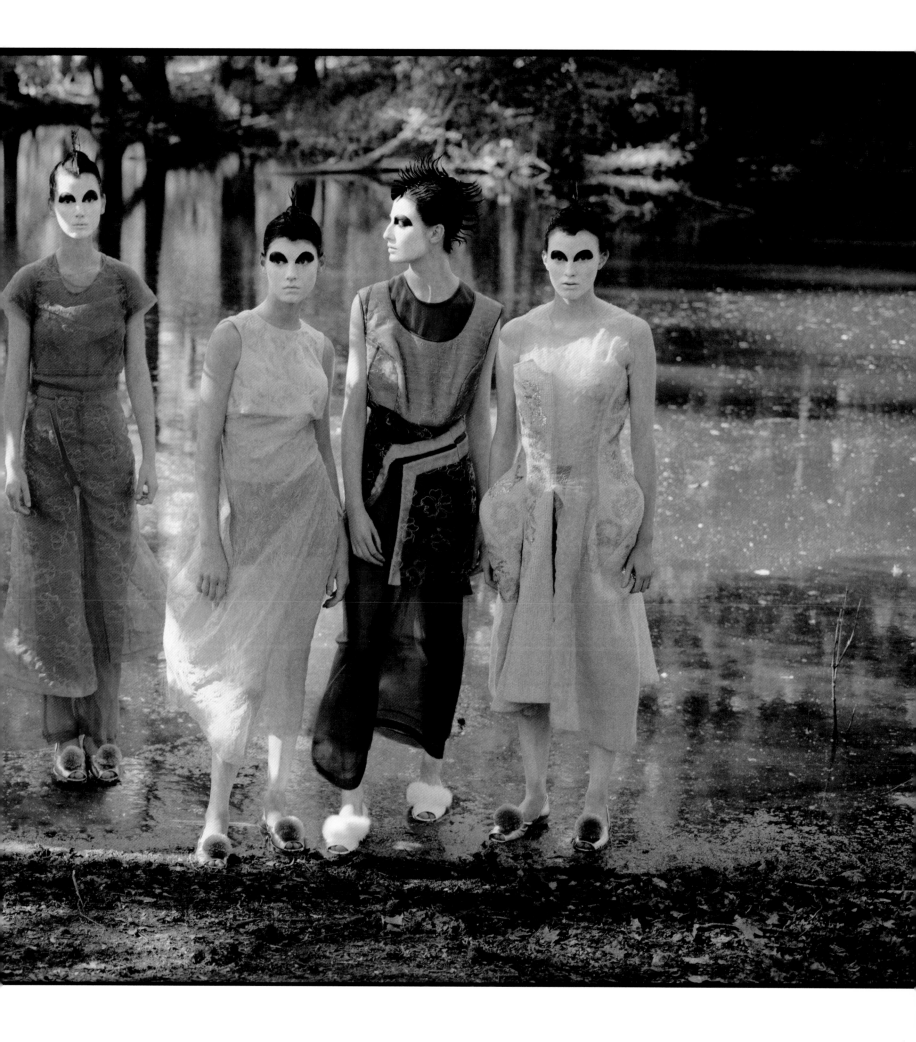

IRVING PENN, *Large Nude Woman Seated ("Epic Proportions")*, April 2004.

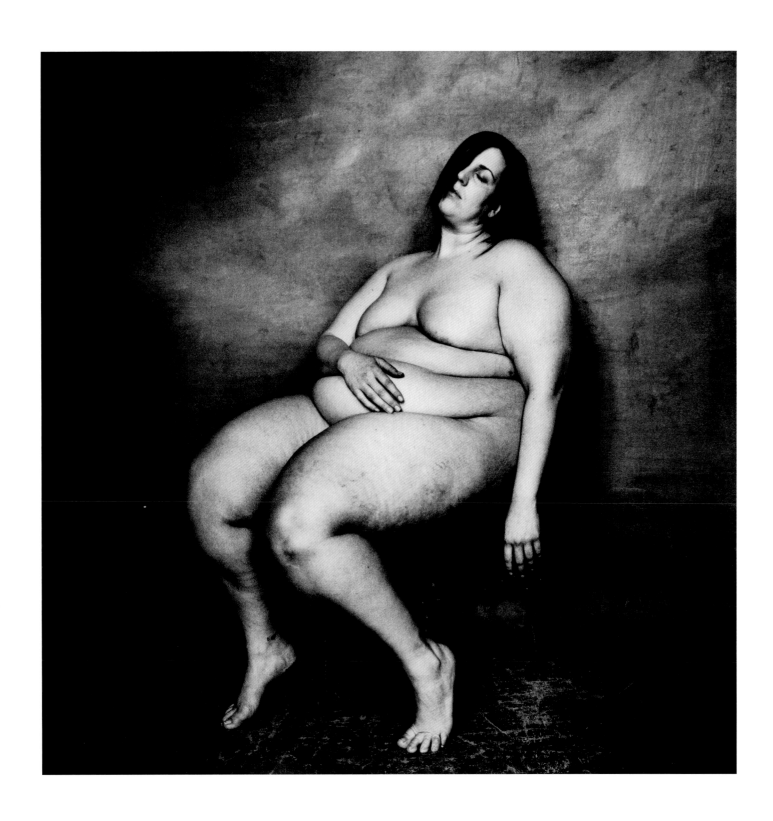

HELMUT NEWTON, *Gold Finger*, April 1995,
© 2009 The Helmut Newton Estate/Maconochie Photography.

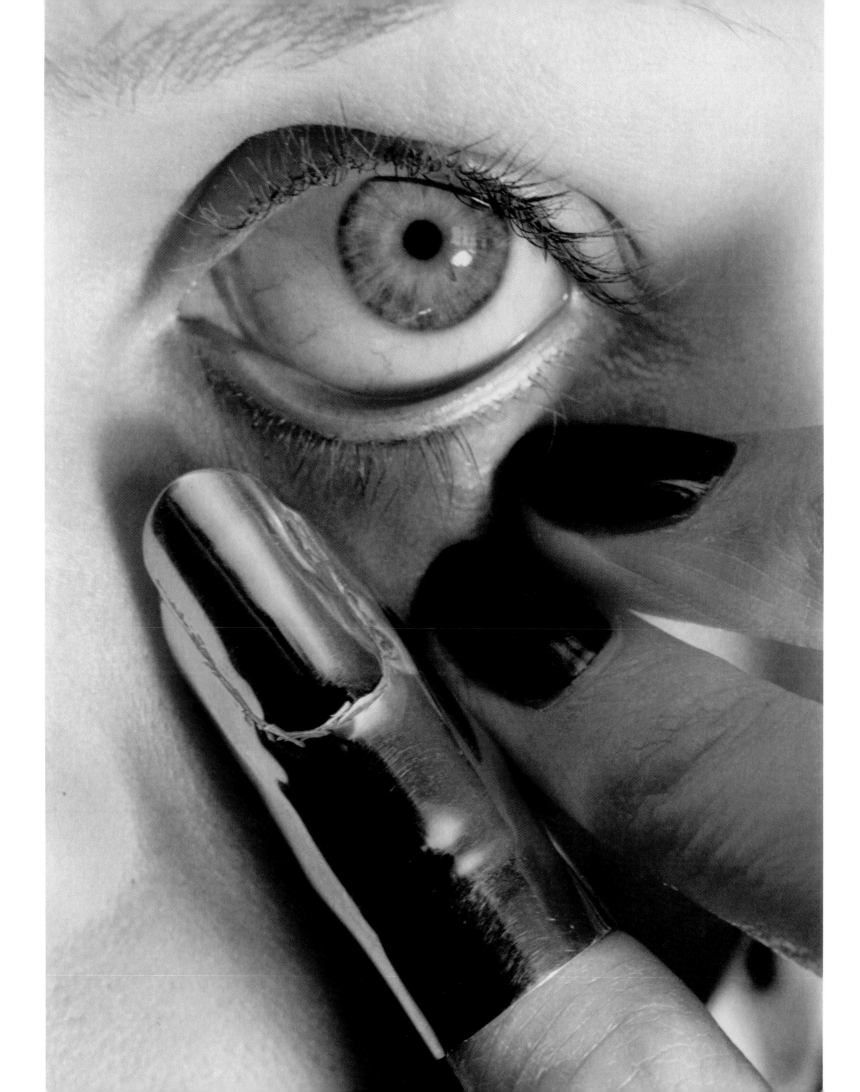

RICHARD AVEDON,
Twiggy, hair by Ara Gallant, Paris studio,
January 1968 (unpublished),
© 2009 The Richard Avedon Foundation.

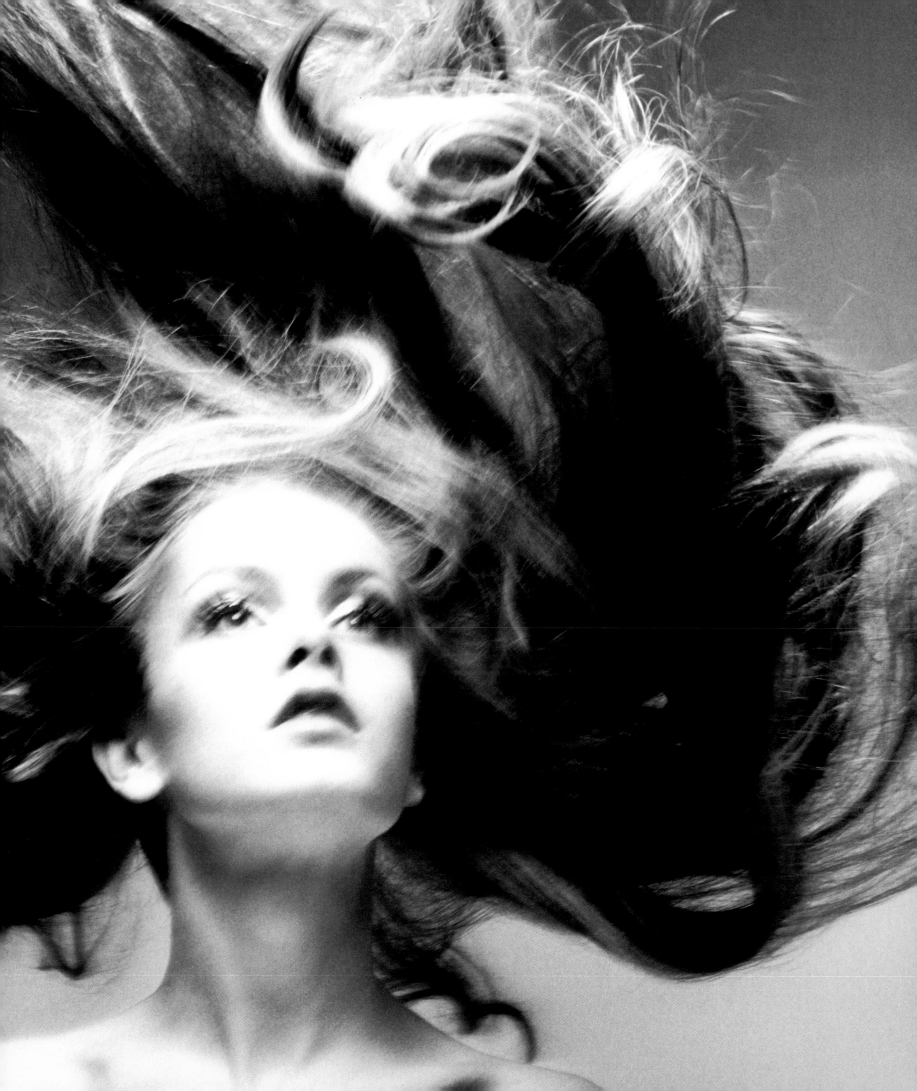

STEVEN KLEIN, *Trouble Spots*, August 2008.

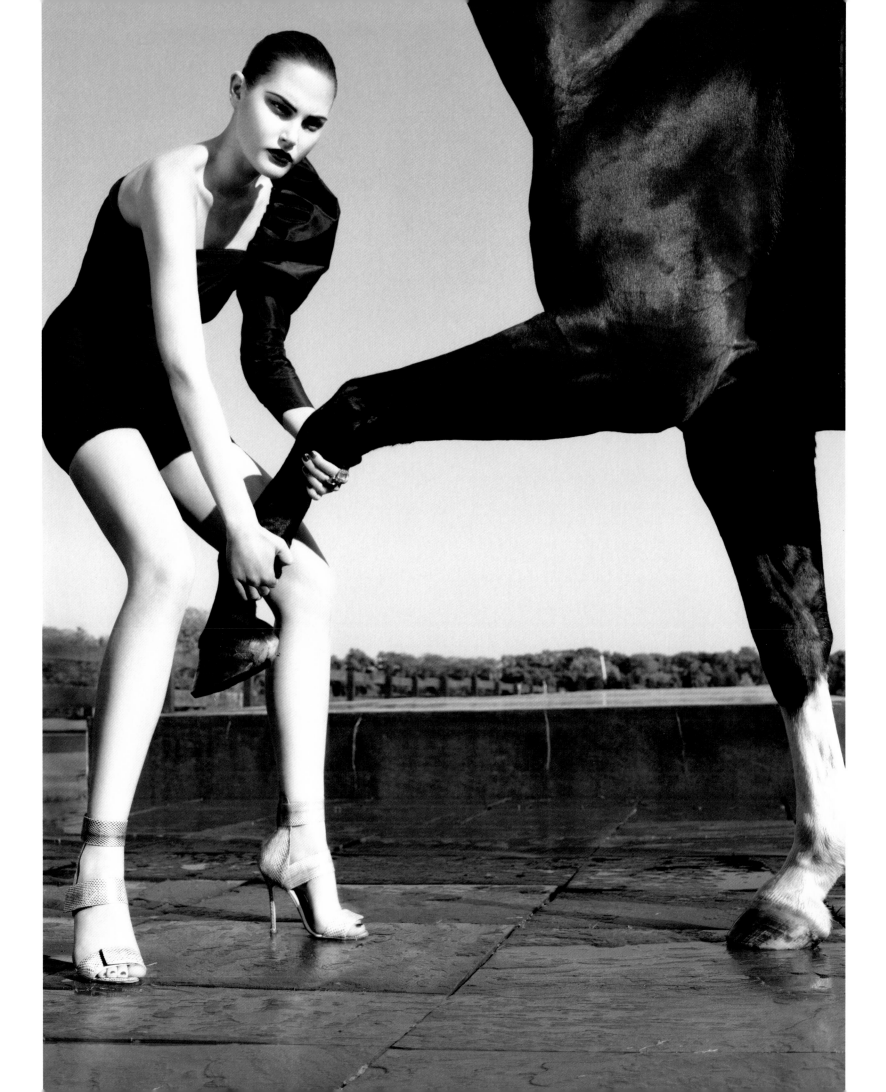

IRVING PENN

IRVING PENN, *Bearded Kuo Koko Head*, December 1966.

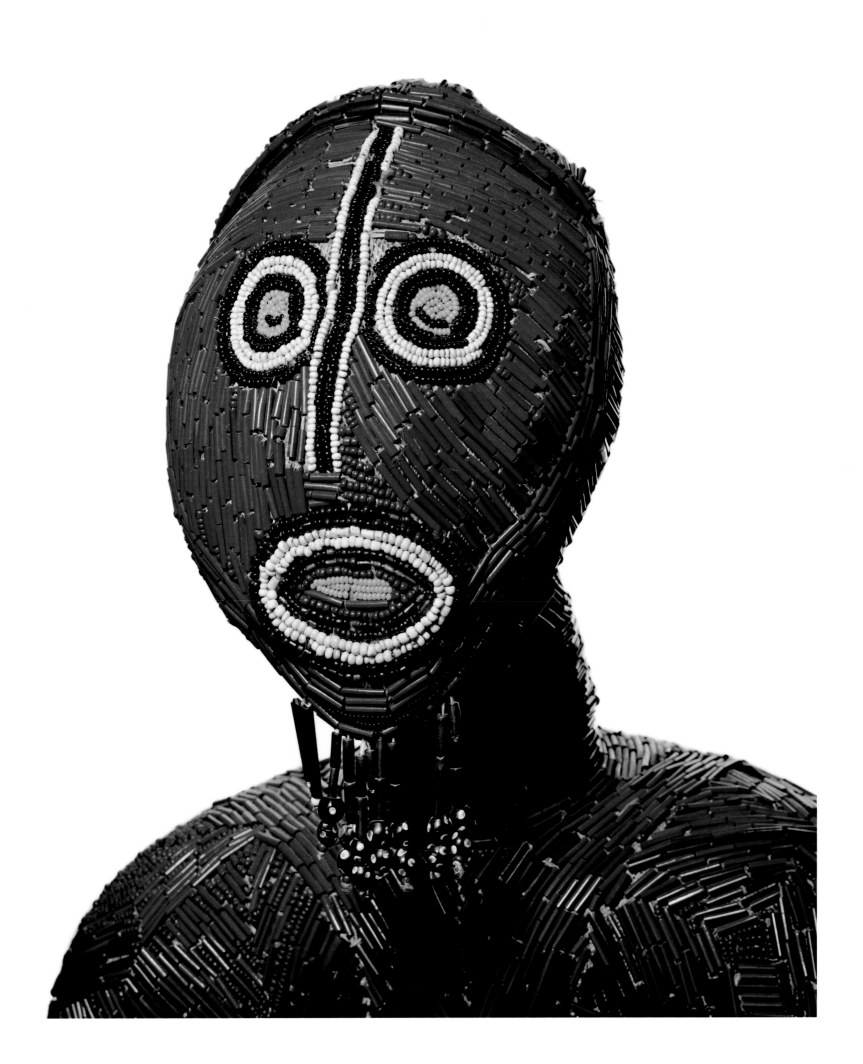

IRVING PENN, *Woman in a Burlap Sack (B)*, July 2007.

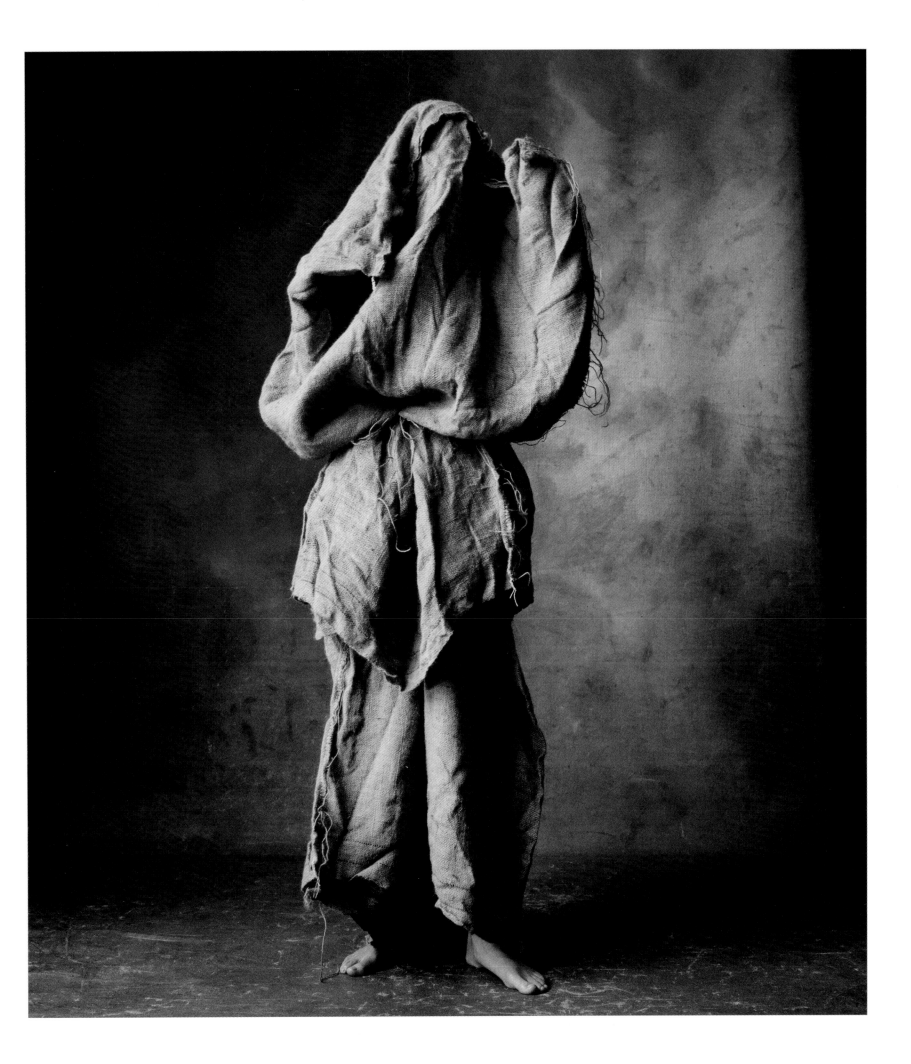

IRVING PENN, *Vegetable Face*, January 1996.

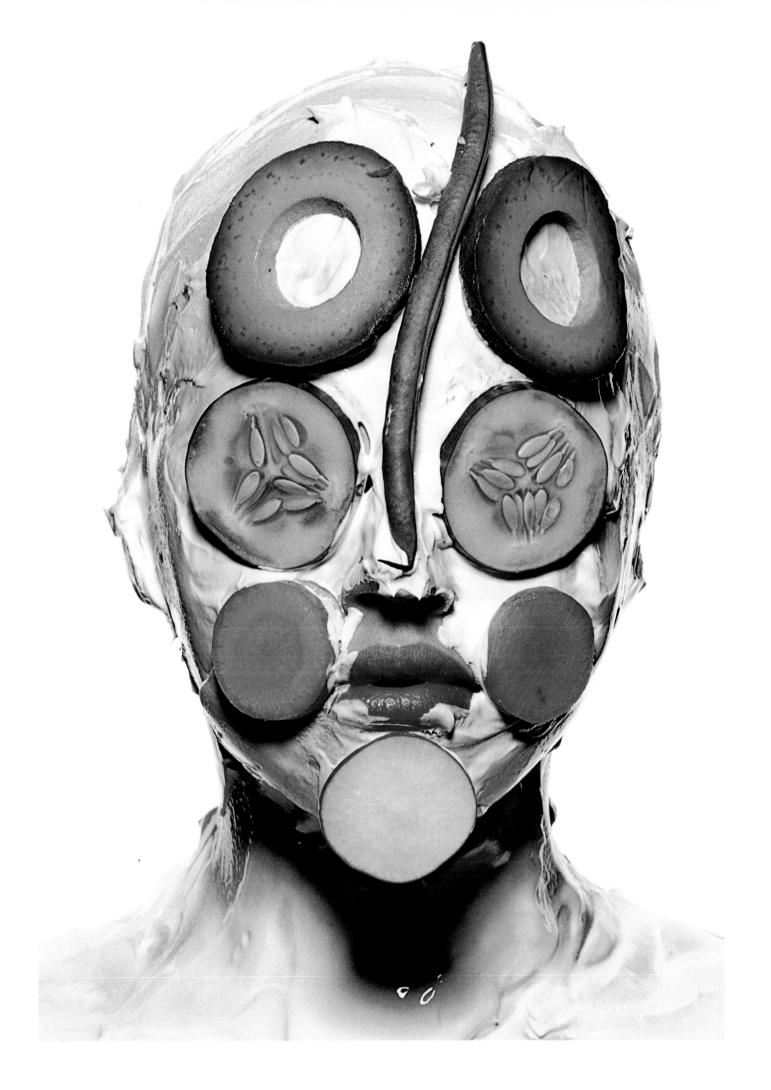

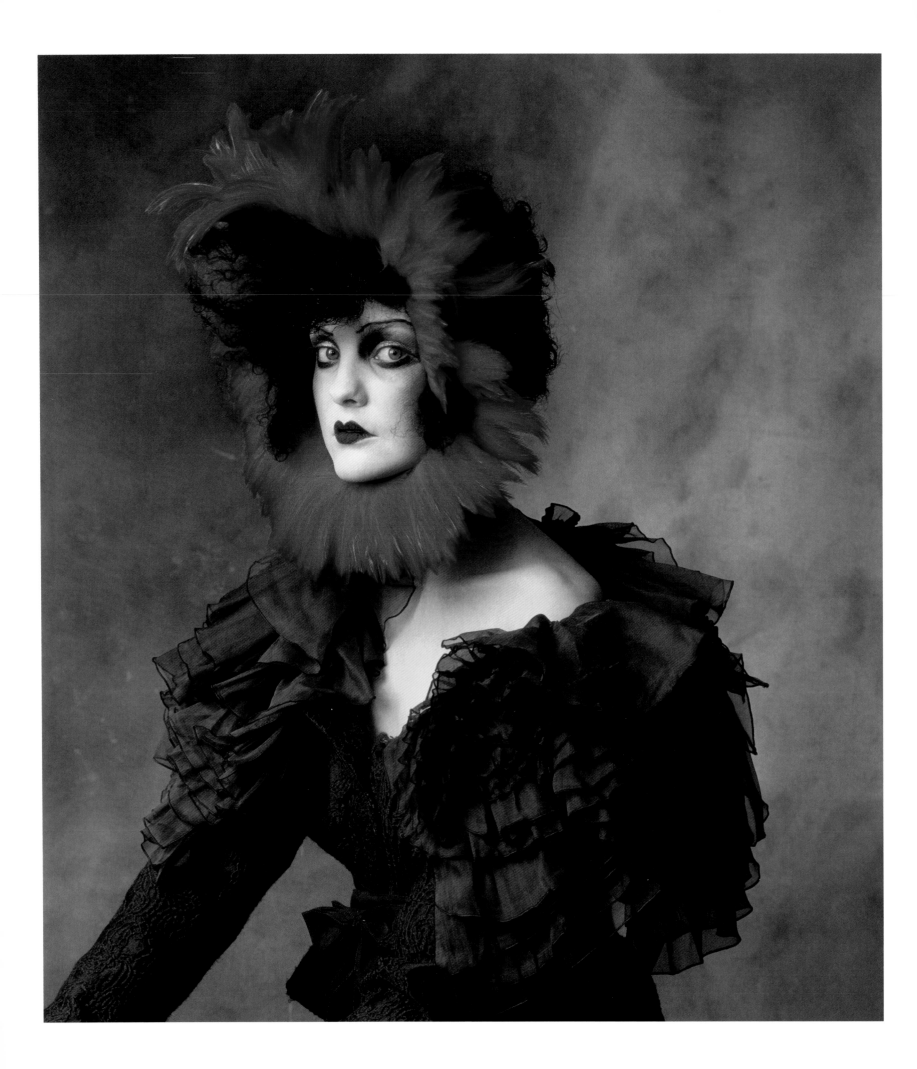

IRVING PENN, *John Galliano Silk Wool Jacquard Jacket with Red Feather Headpiece*, July 2007.

IRVING PENN, *Bee on Lips*, December 1995.

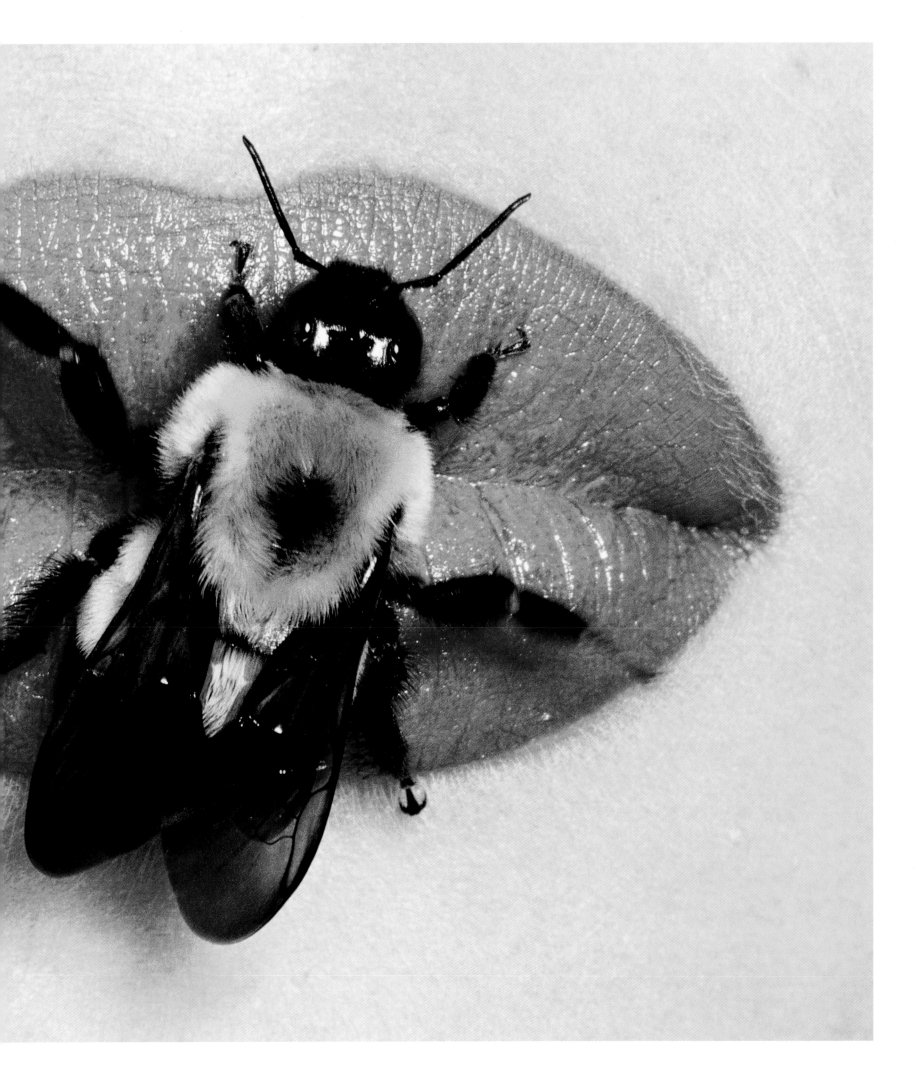

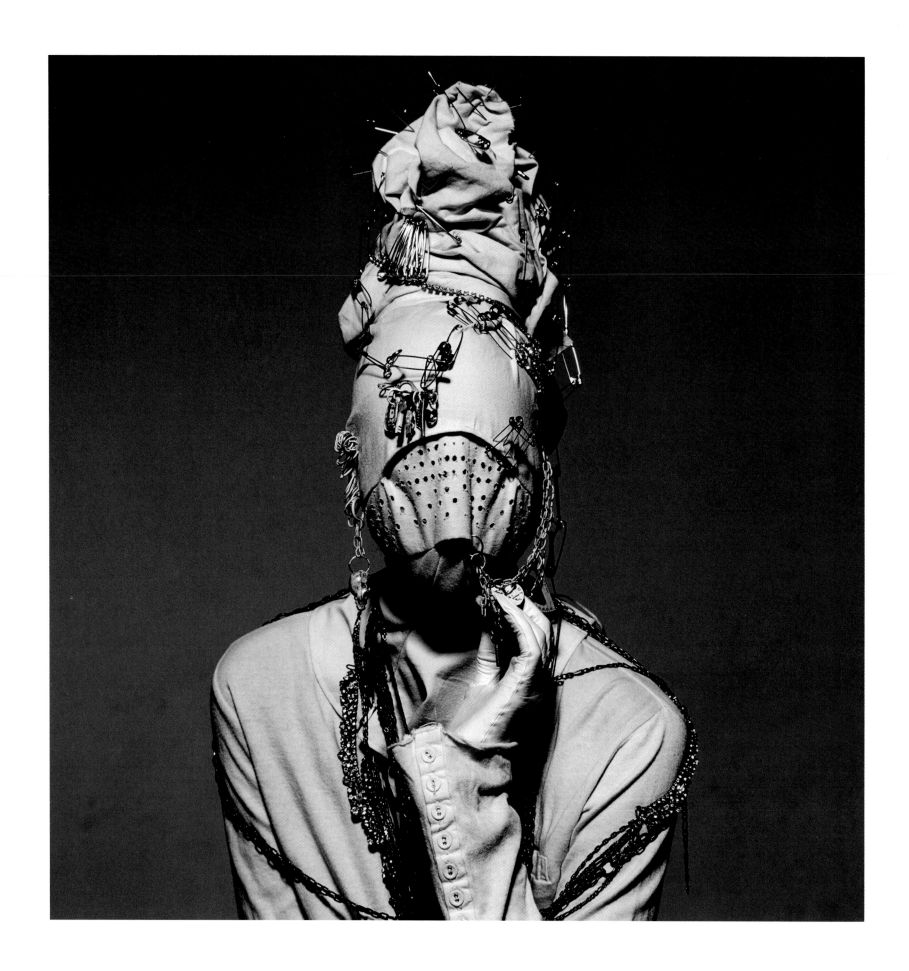

IRVING PENN, *Canvas Head with Hardware (Design by Jun Takahashi)*, September 2006.
RIGHT: IRVING PENN, *Foot Care*, March 1991.

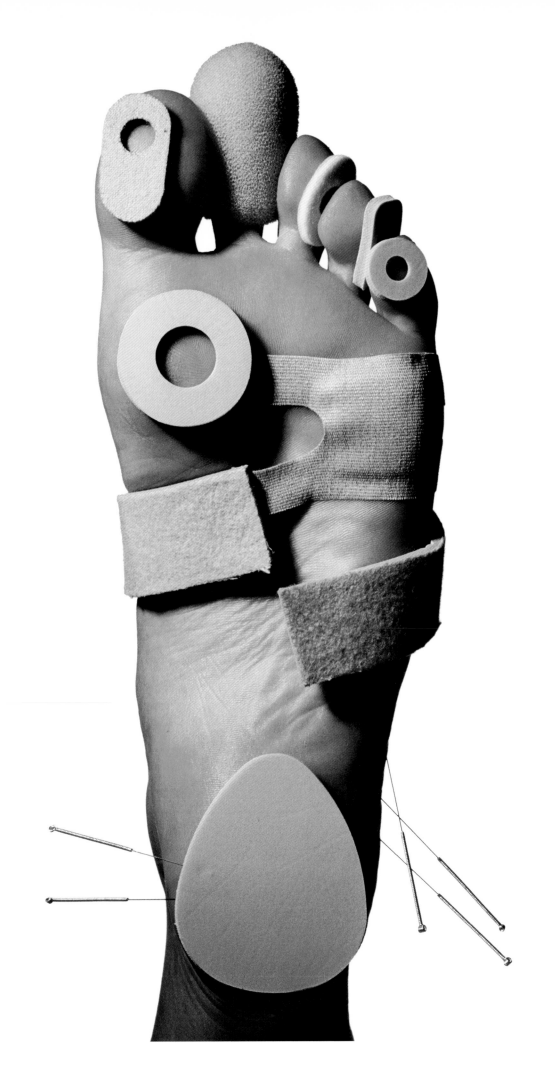

IRVING PENN, *Beauty Treatment with Gauze Mask*, December 1997.

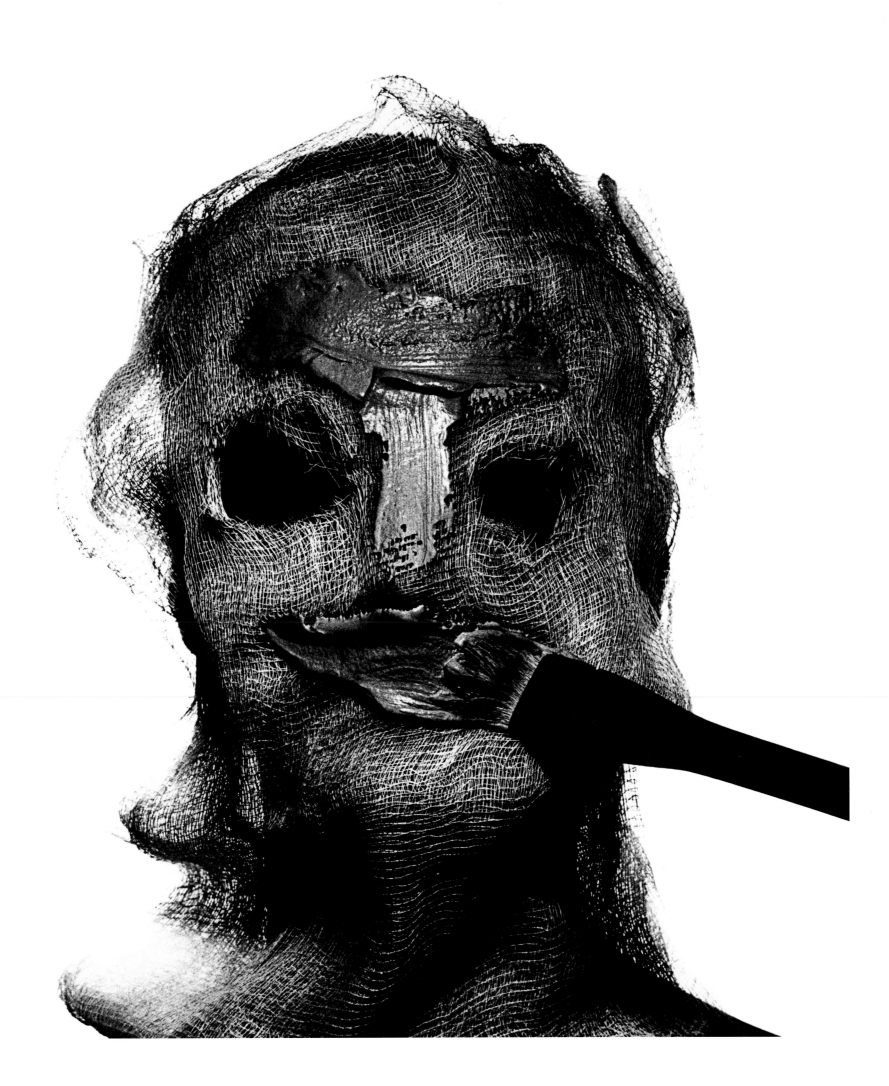

IRVING PENN, *Cult Creams*, June 1996.

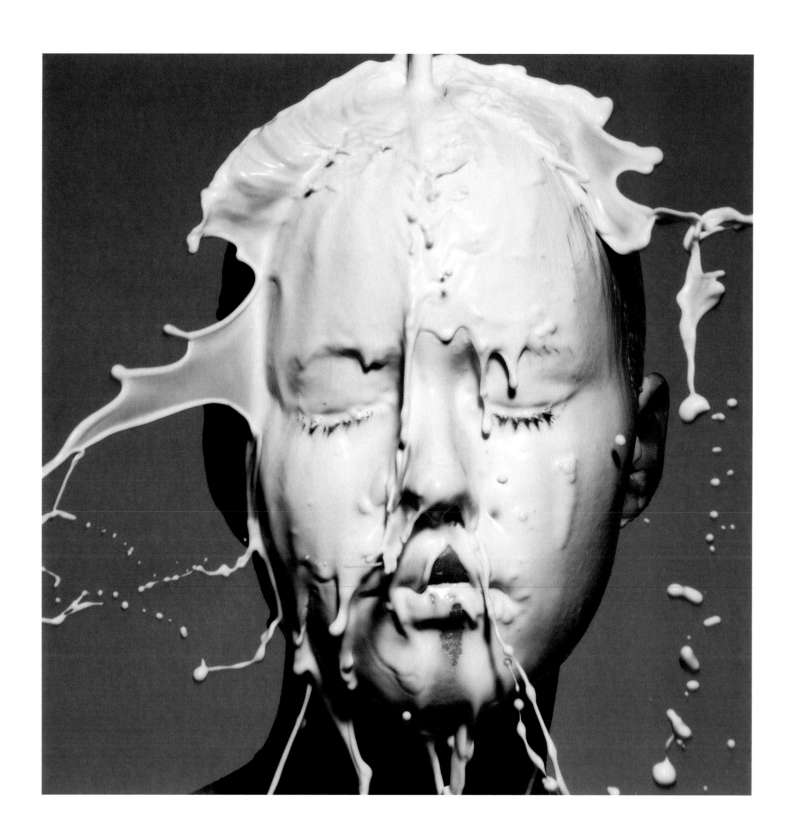

IRVING PENN, *Cleopatra's Eye*, August 1990.

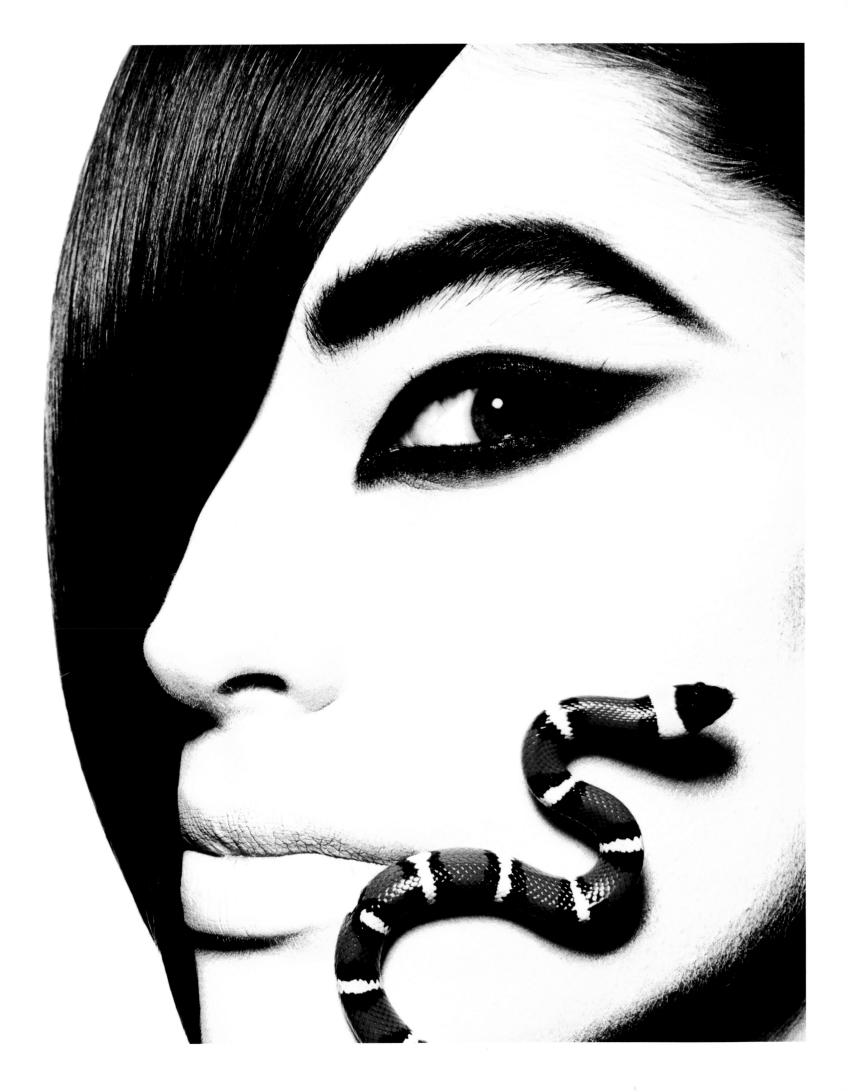

IRVING PENN, *Corset (Karl Lagerfeld for Chanel Couture)*, October 1994.

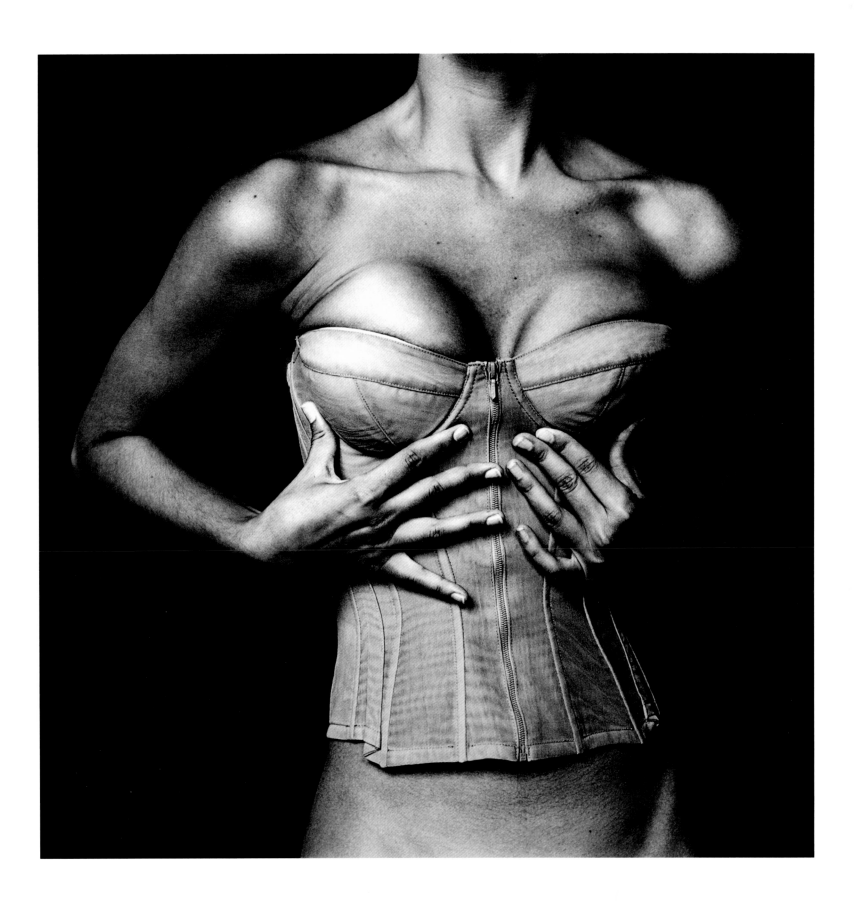

IRVING PENN, *Still Life with Snails*, May 1989.

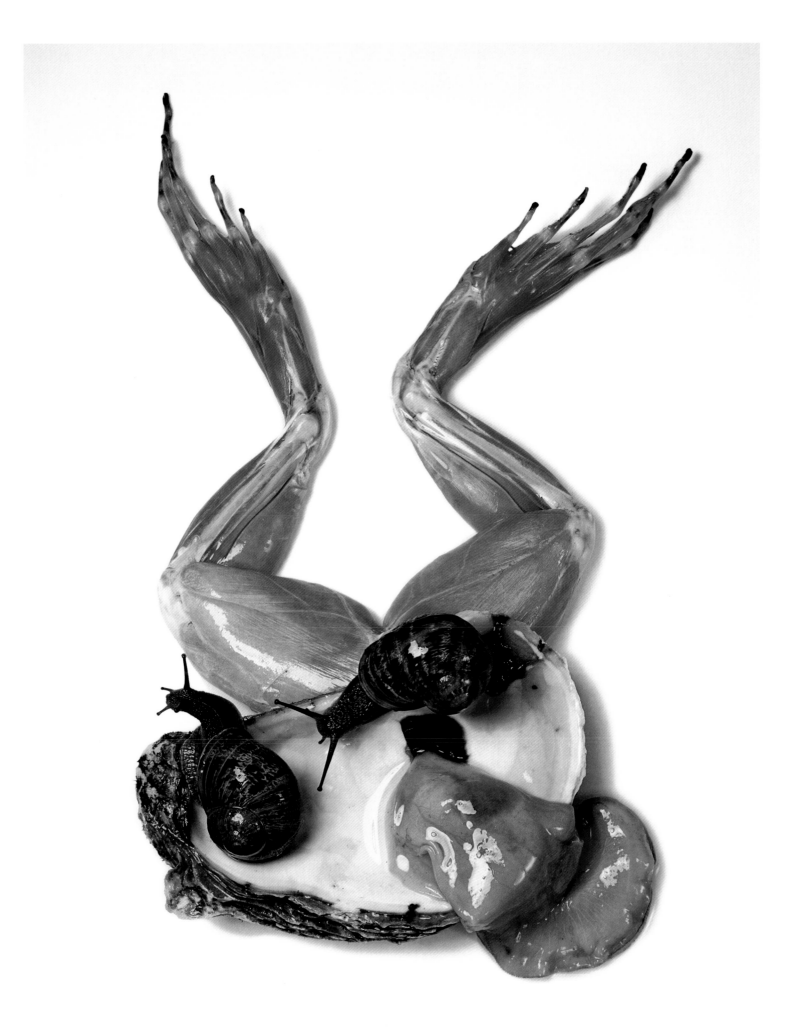

IRVING PENN, *The Small Waist*, August 2000.

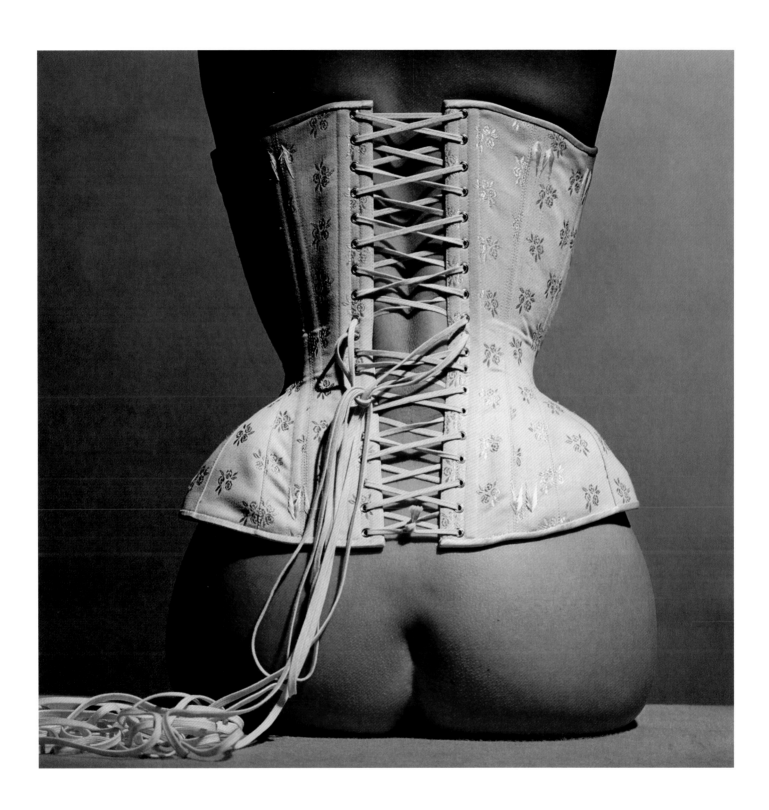

IRVING PENN, *Chastity Belt*, April 2002.

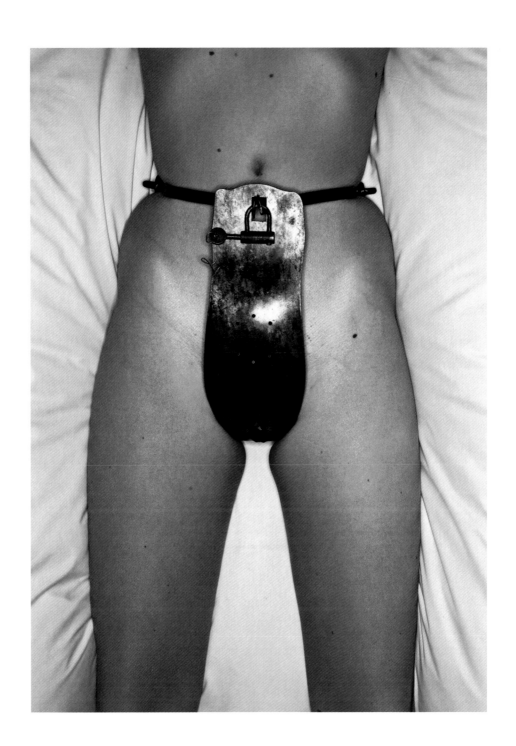

IRVING PENN, *Football Face*, November 2002.

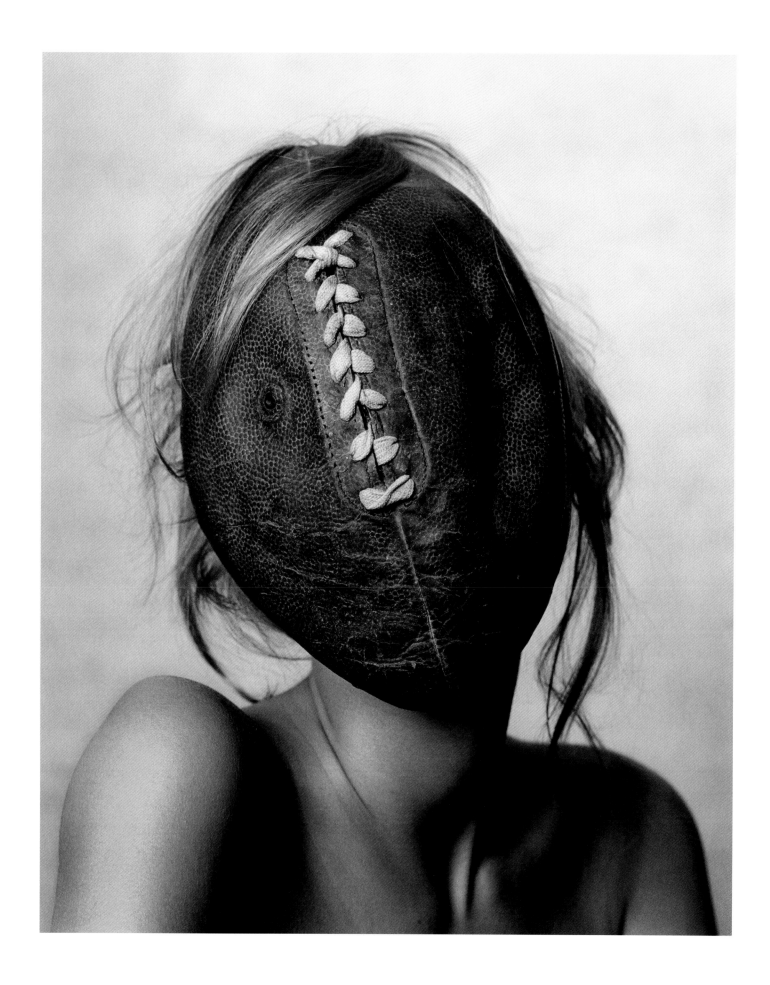

IRVING PENN, *Chocolate Mouth*, February 2001.

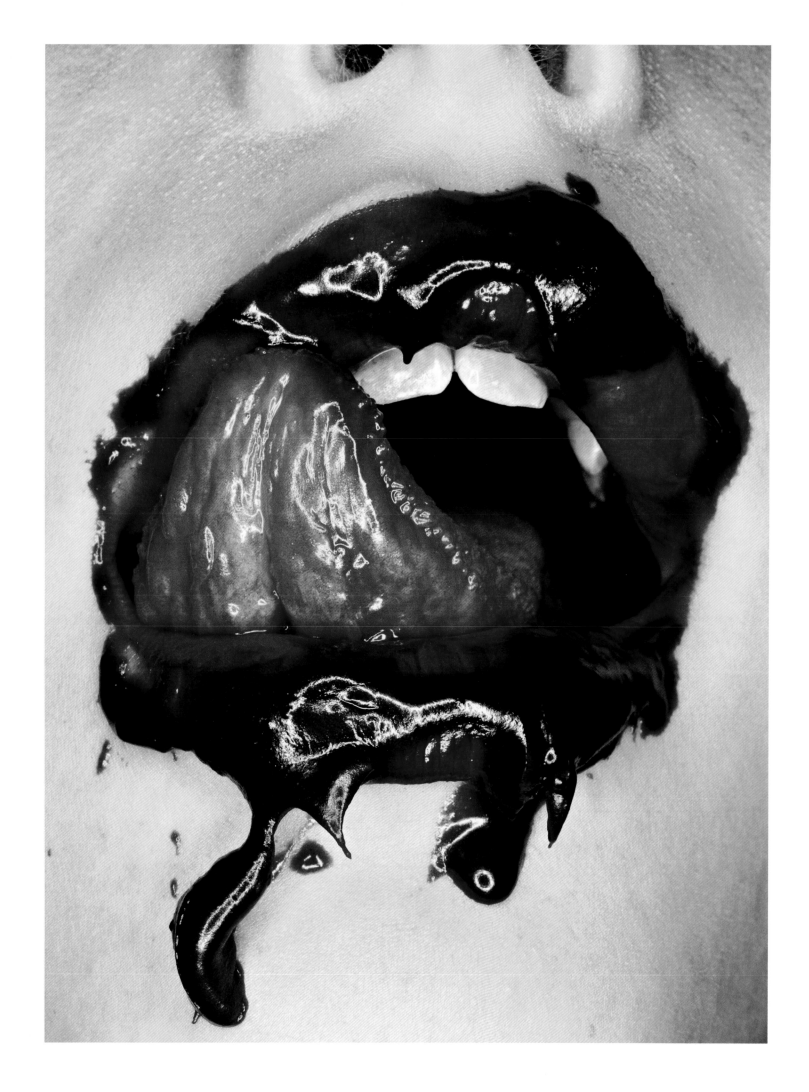

IRVING PENN, *Bull's Eye Contact Lens (B)*, September 1983.

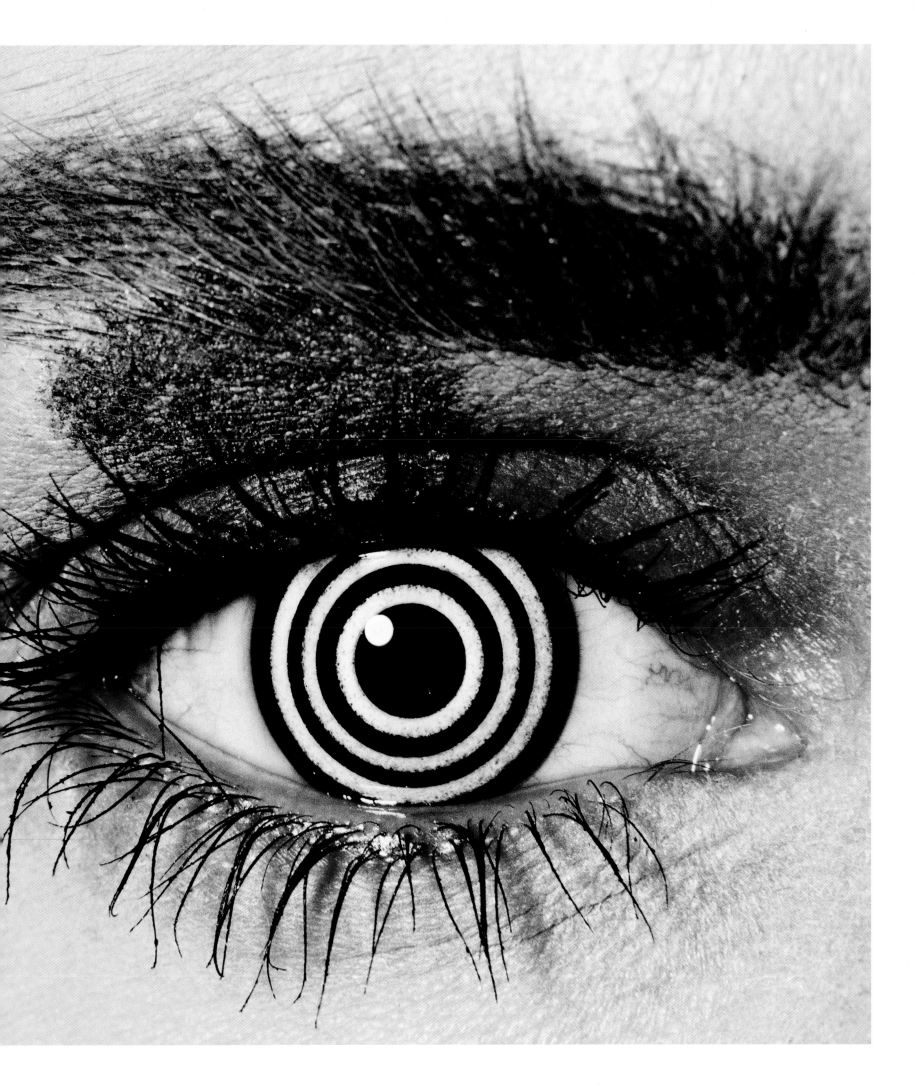

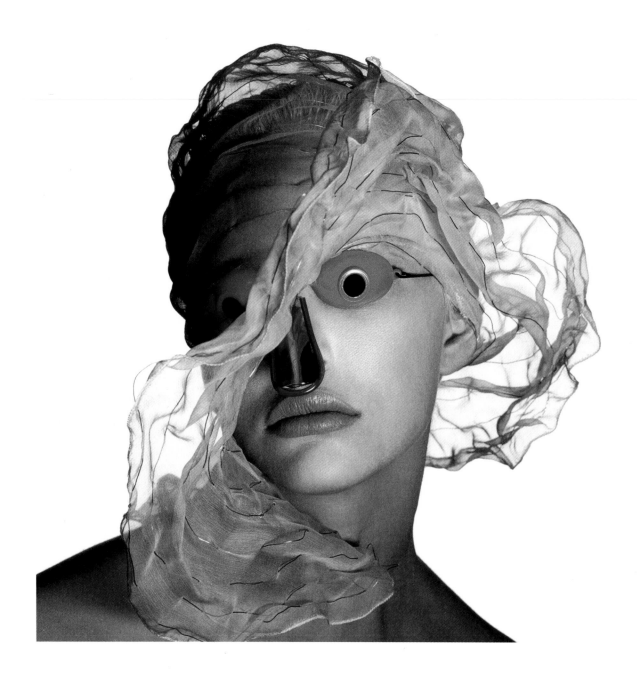

IRVING PENN, *Girl with Tiny Goggles*, April 1994.
RIGHT: IRVING PENN, *Clear Plastic Beauty Mask (B)*, November 1996.

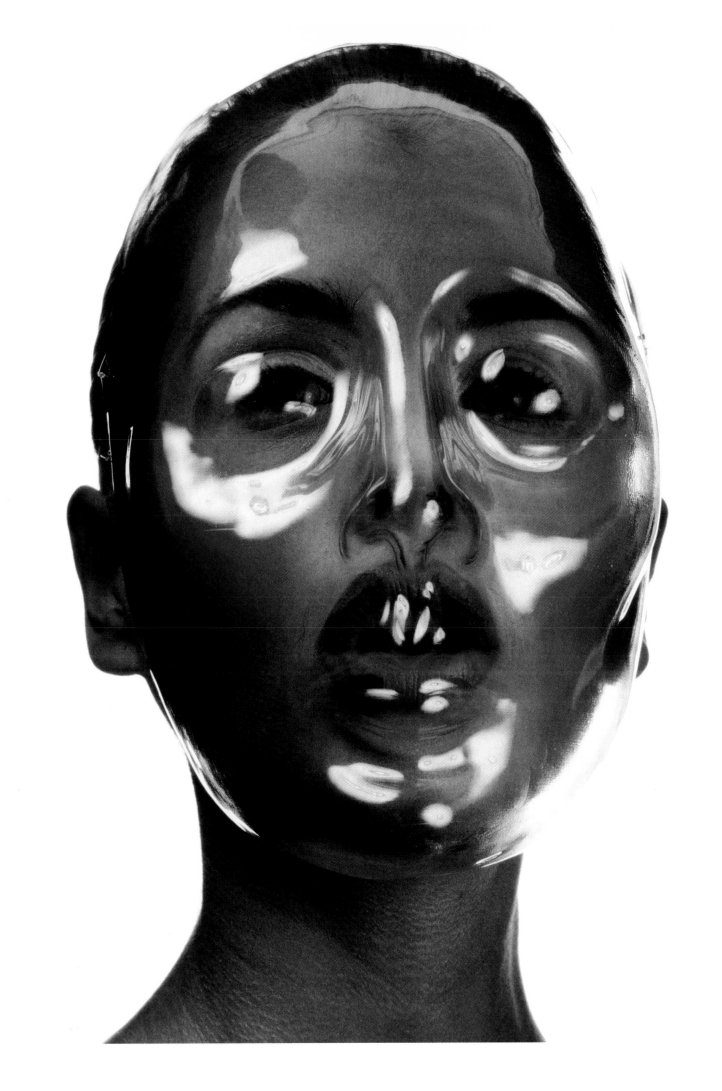

IRVING PENN, *Turkey Neck*, August 2003.

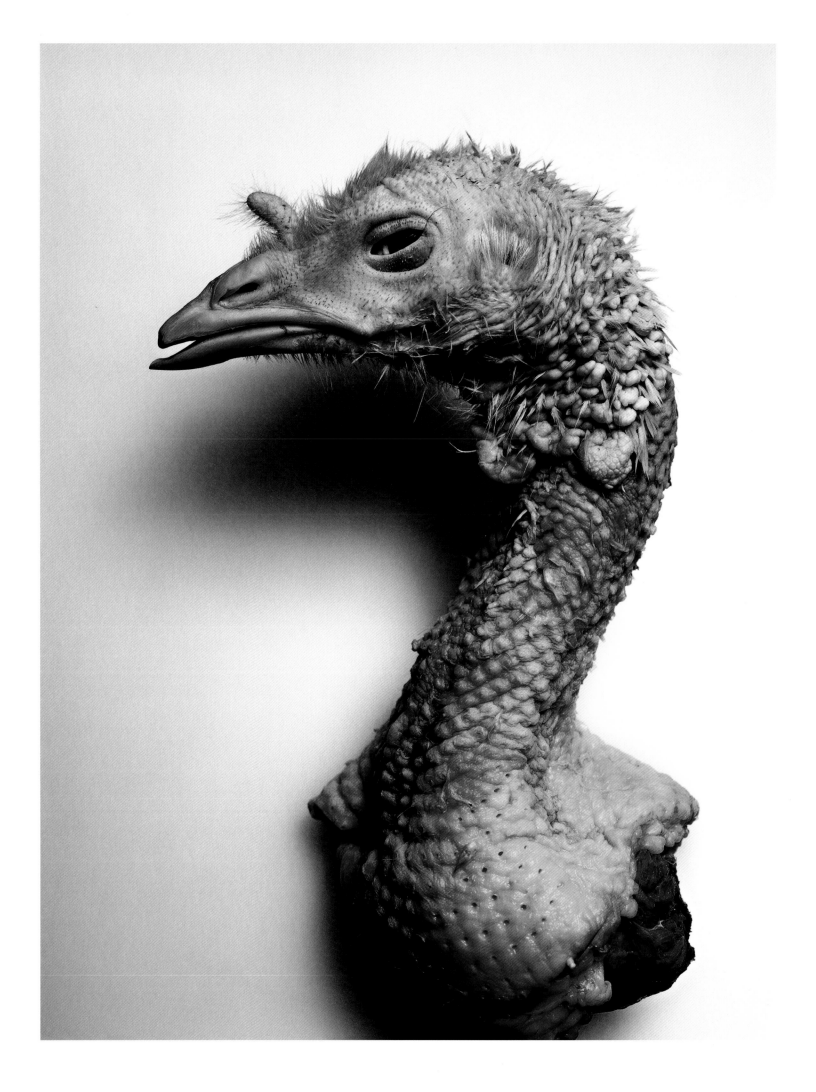

IRVING PENN, *Yves Saint Laurent Blouse*, December 2005.

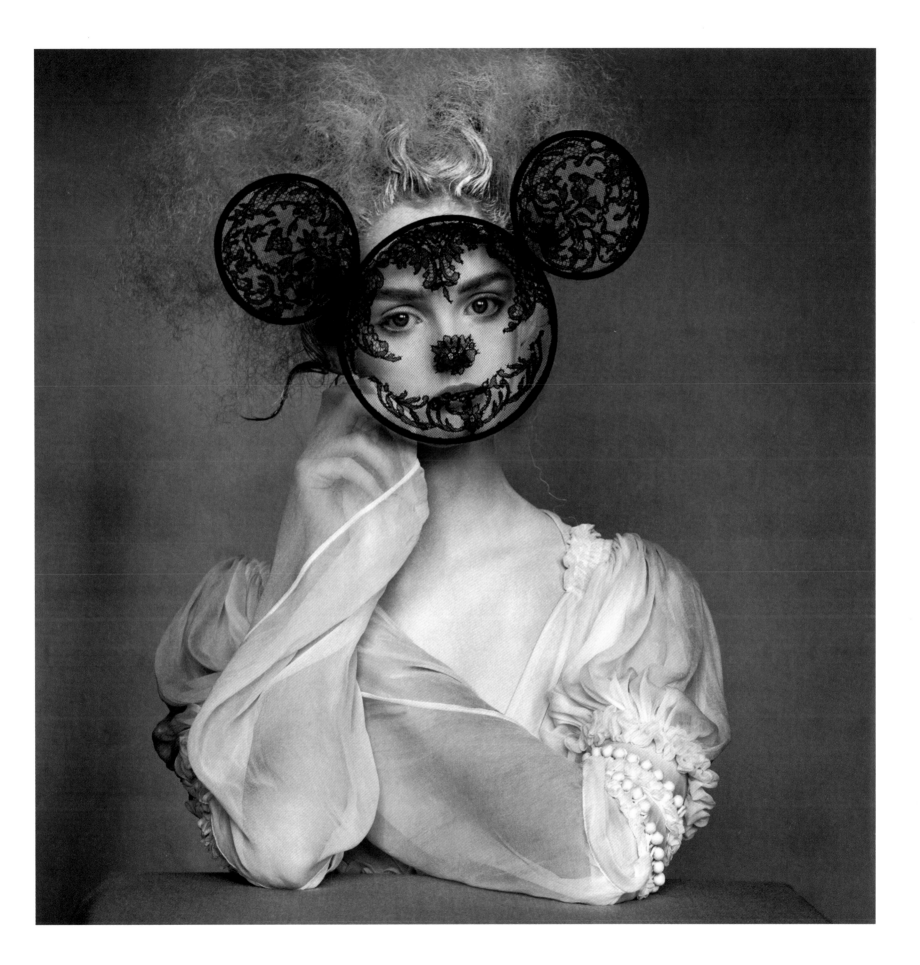

BODIES,
UNLEASHED

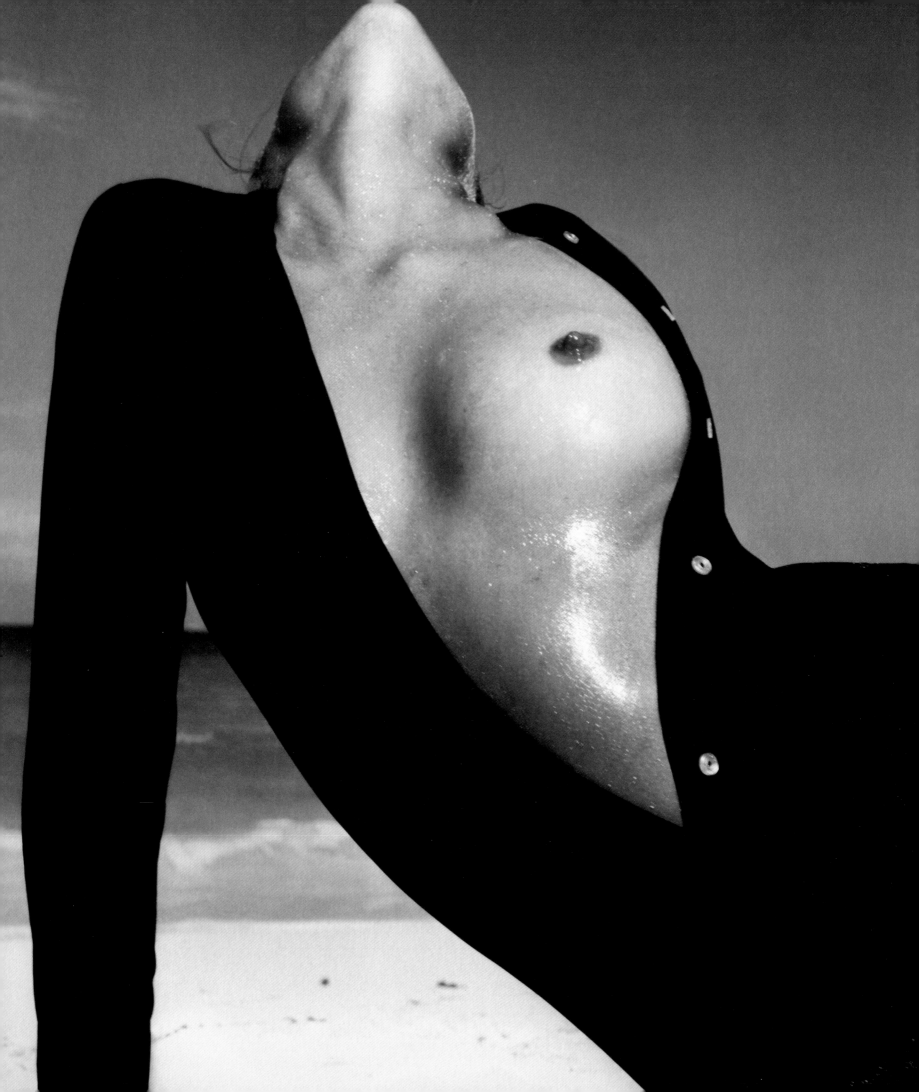

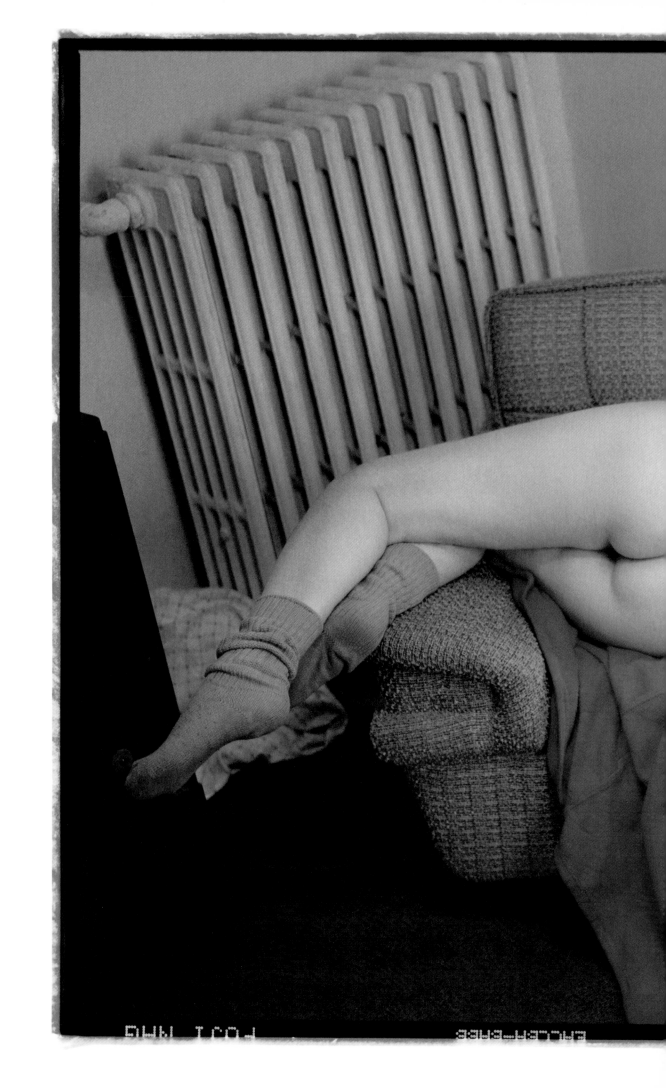

ANNIE LEIBOVITZ,
Karen Finley, November 1999.

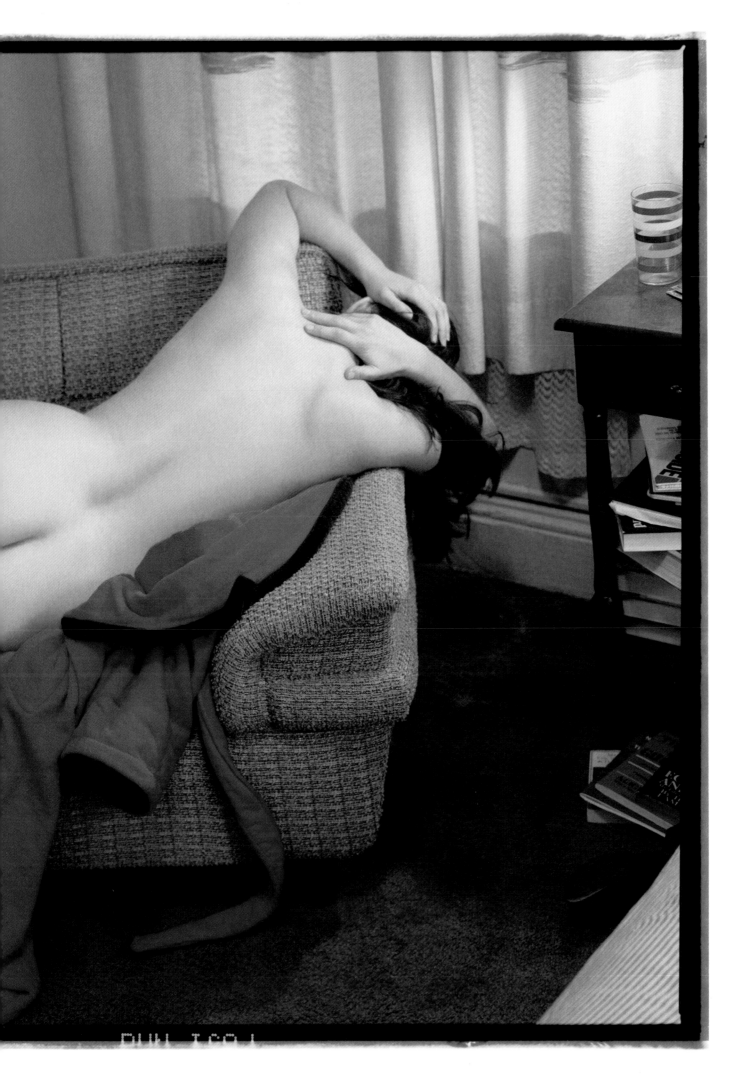

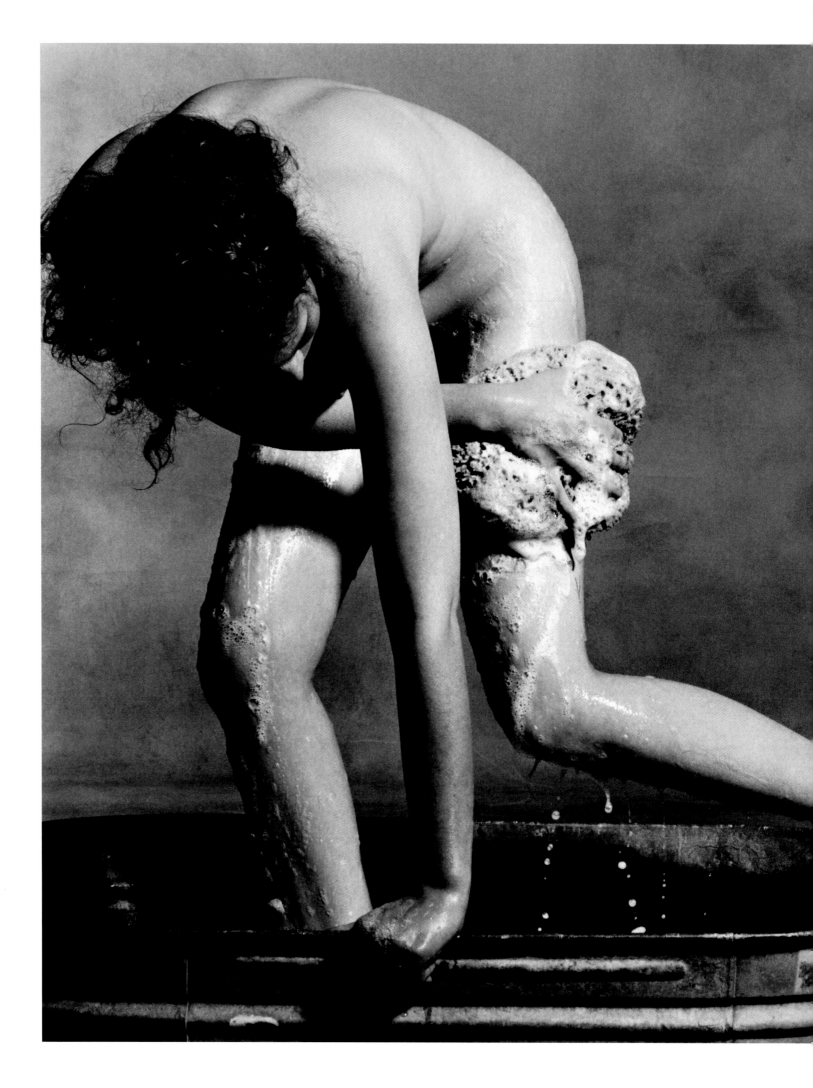

IRVING PENN, *Bathing Nude: Sponge on Hip (B)*, February 1979.

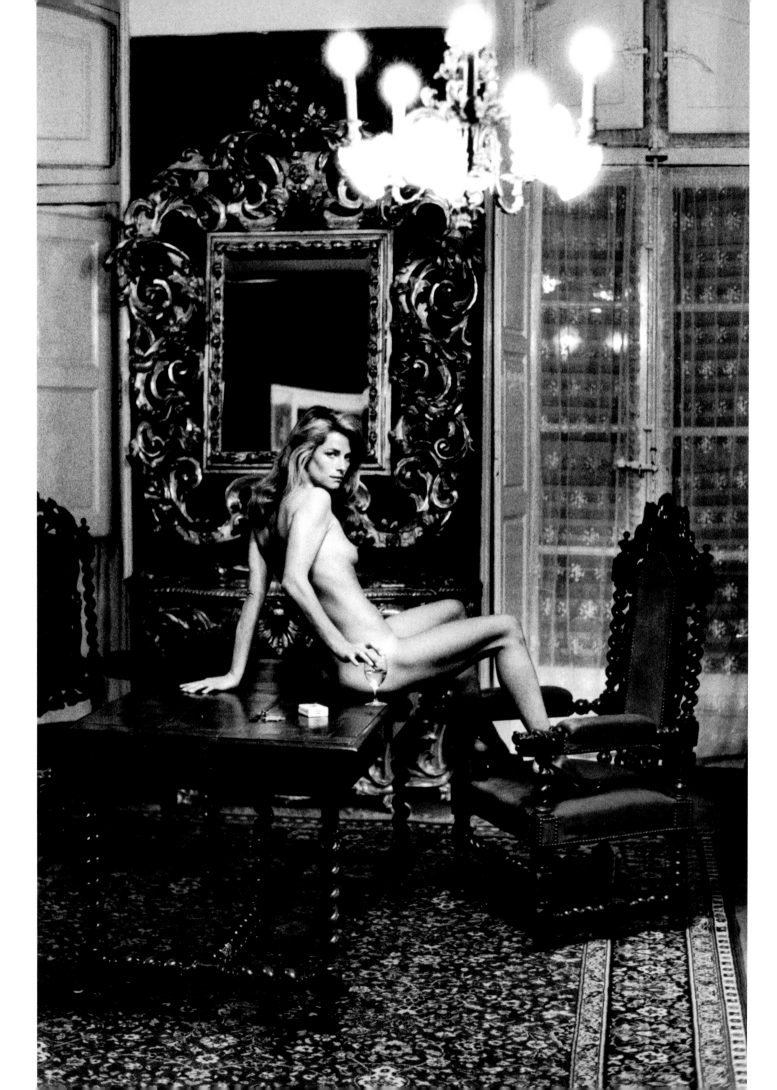

HELMUT NEWTON, *Sexiest Woman in the World—Charlotte Rampling,* December 1974,
© 2009 The Helmut Newton Estate/Maconochie Photography.

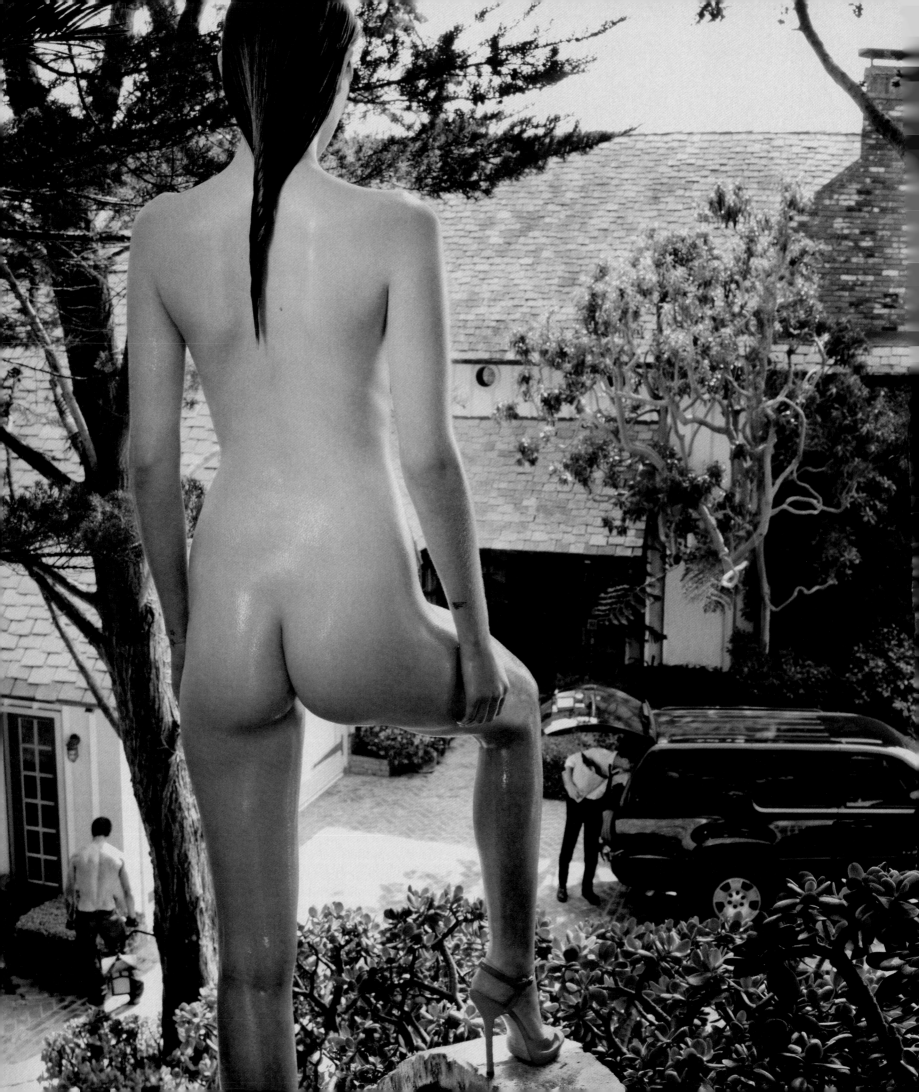

STEVEN KLEIN, *Untitled*, May 2009.

STEVEN KLEIN, *Dream Cream*, January 2002.

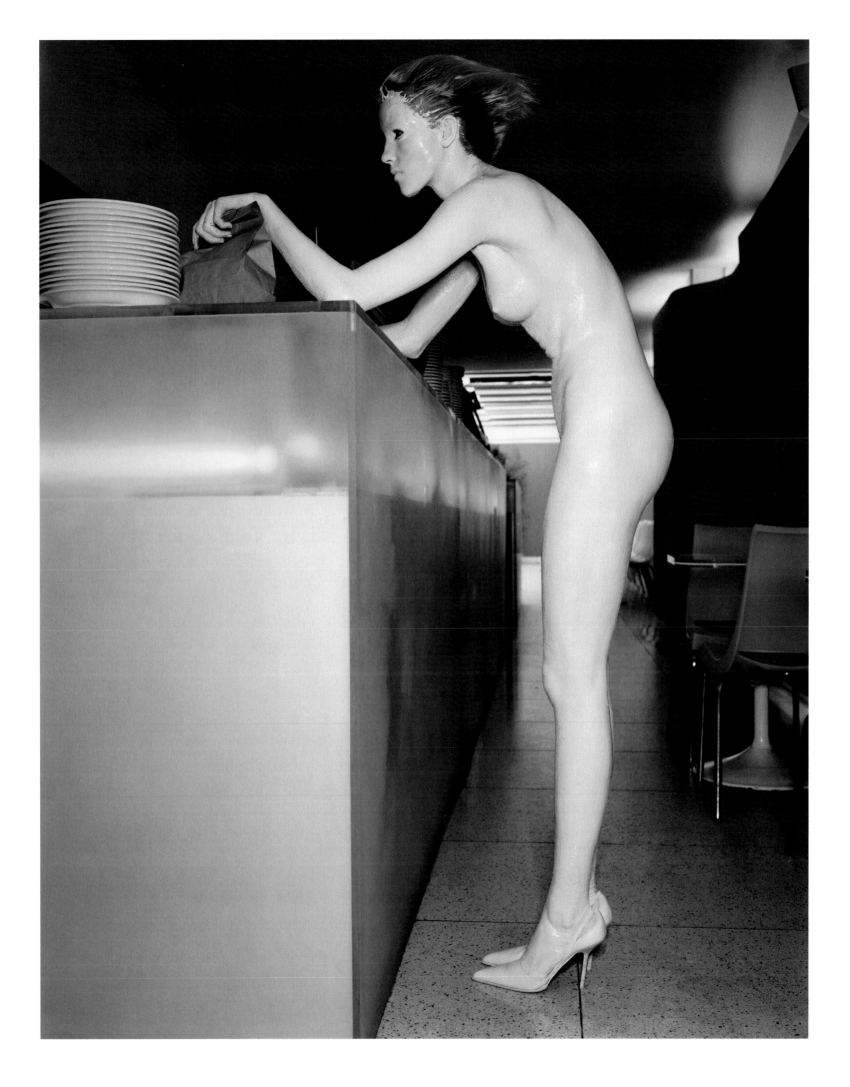

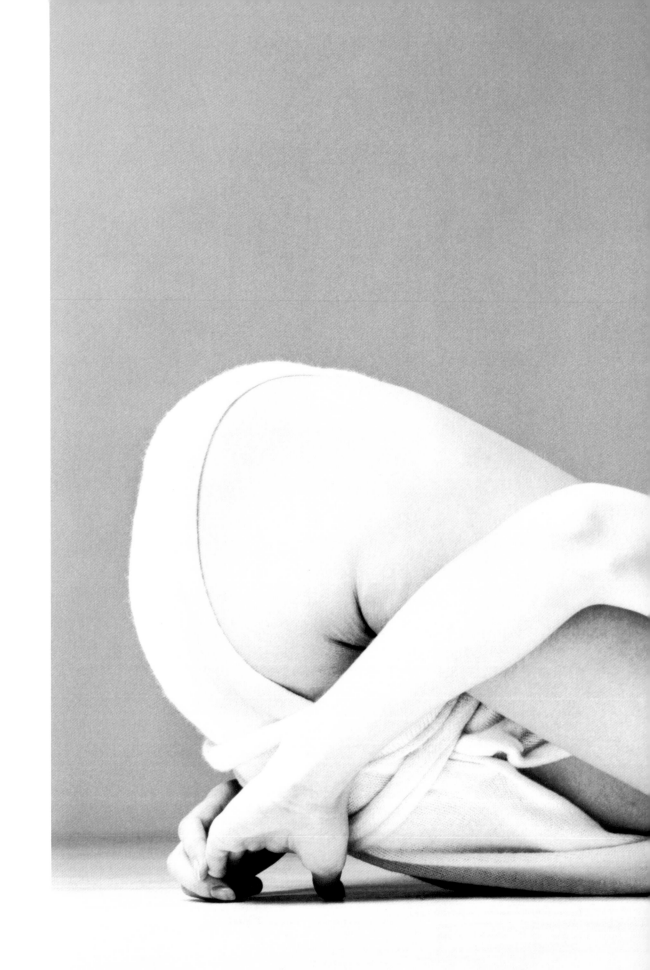

RICHARD AVEDON,
Veruschka, wrap by Giorgio di Sant'Angelo,
New York, March 1972,
© 2009 The Richard Avedon Foundation.

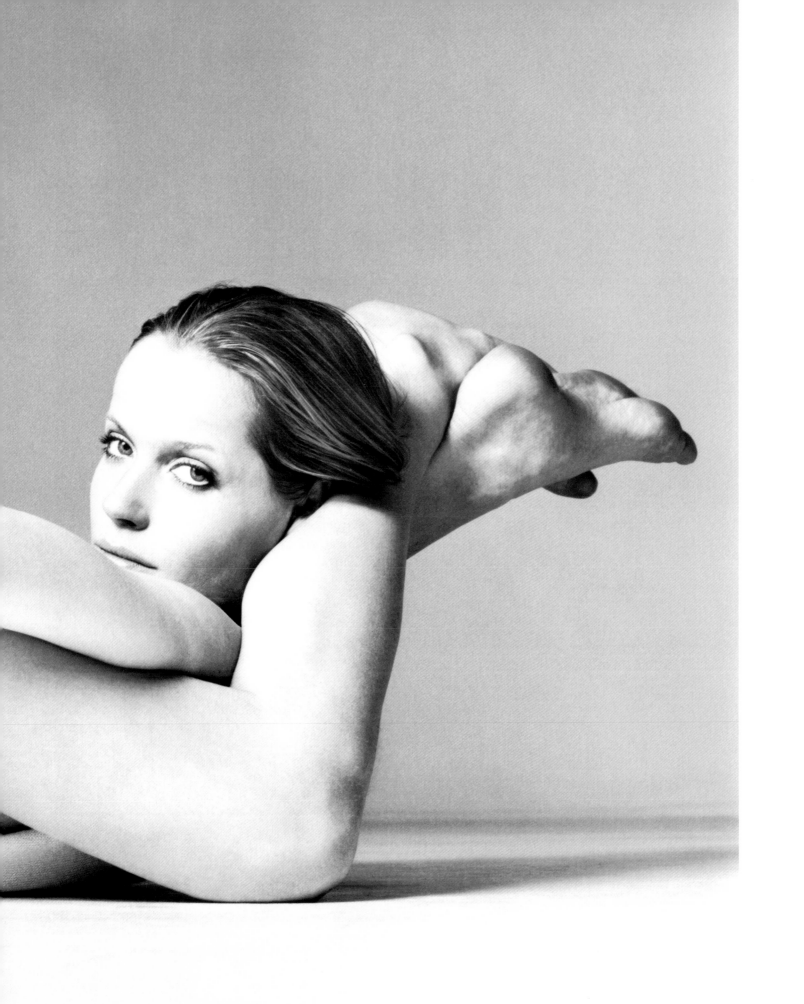

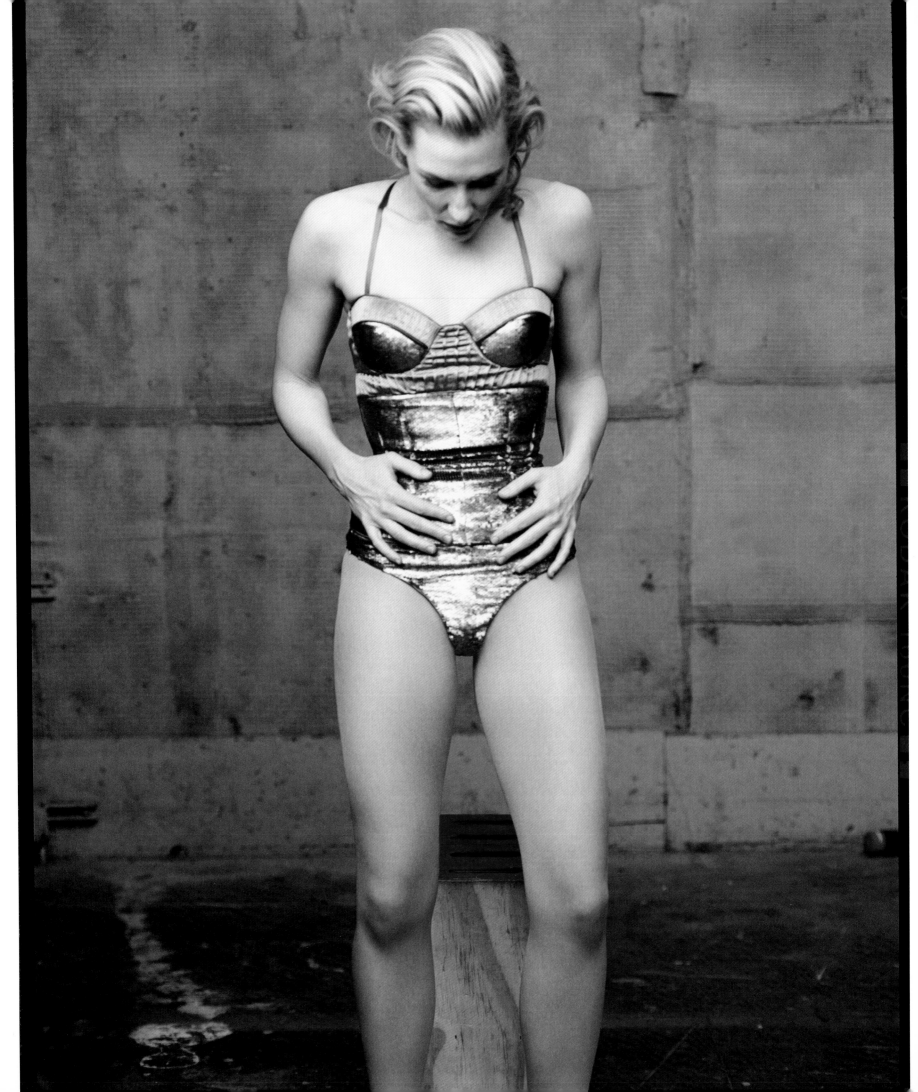

ANNIE LEIBOVITZ, *Cate Blanchett*, December 2004.

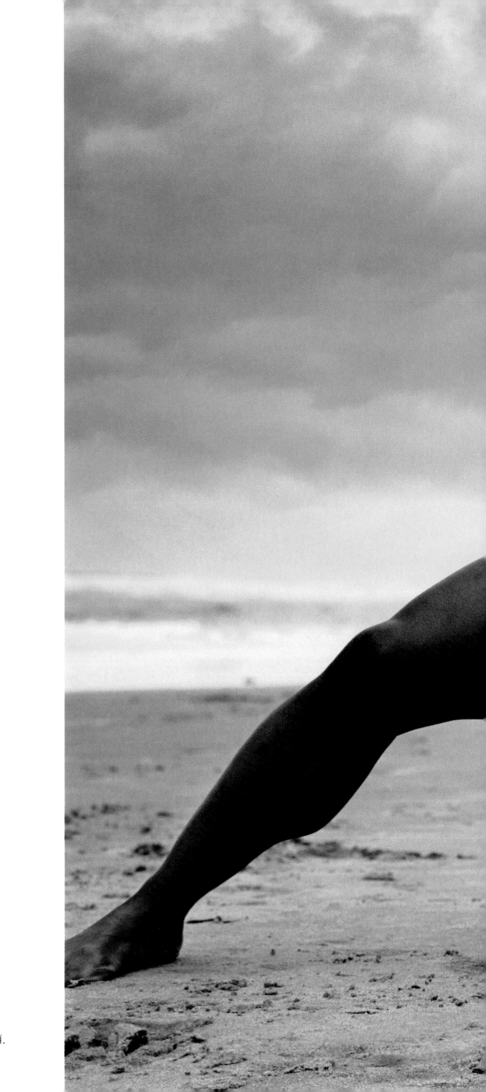

ANNIE LEIBOVITZ,
Tina George and Natalie Coughlin, Black's Beach, San Diego, July 2004.

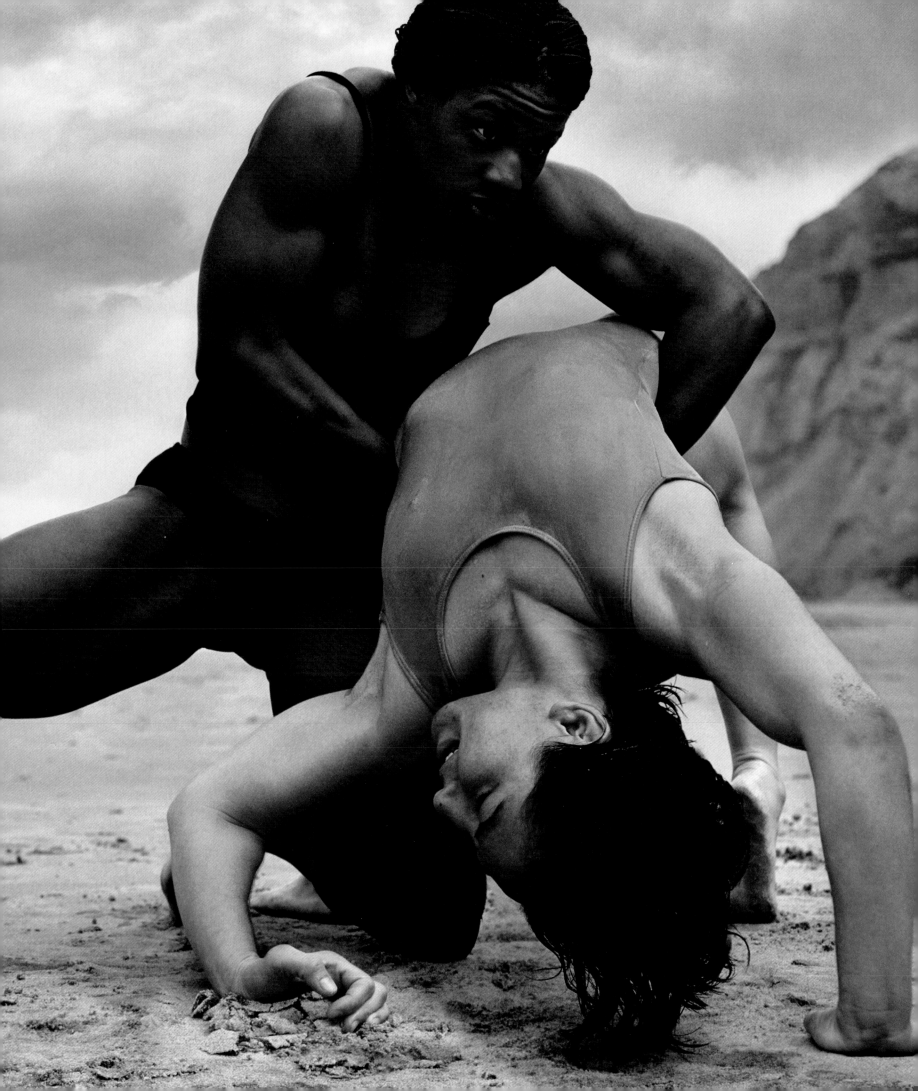

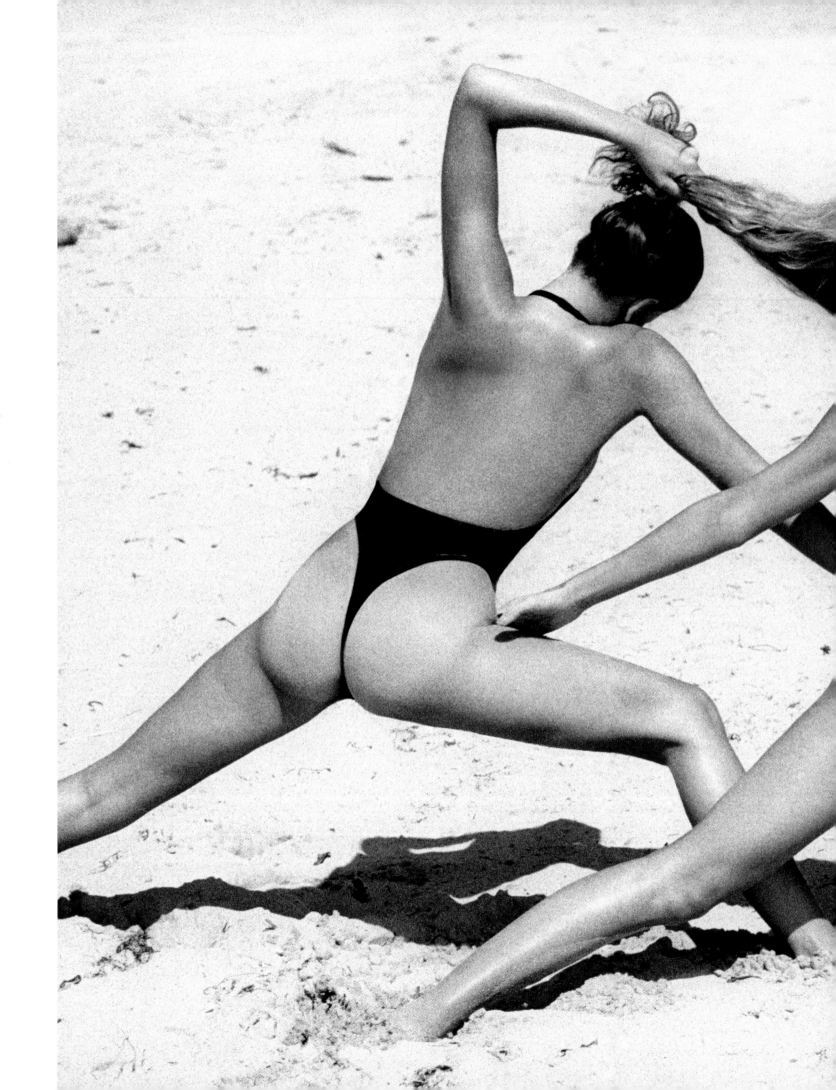

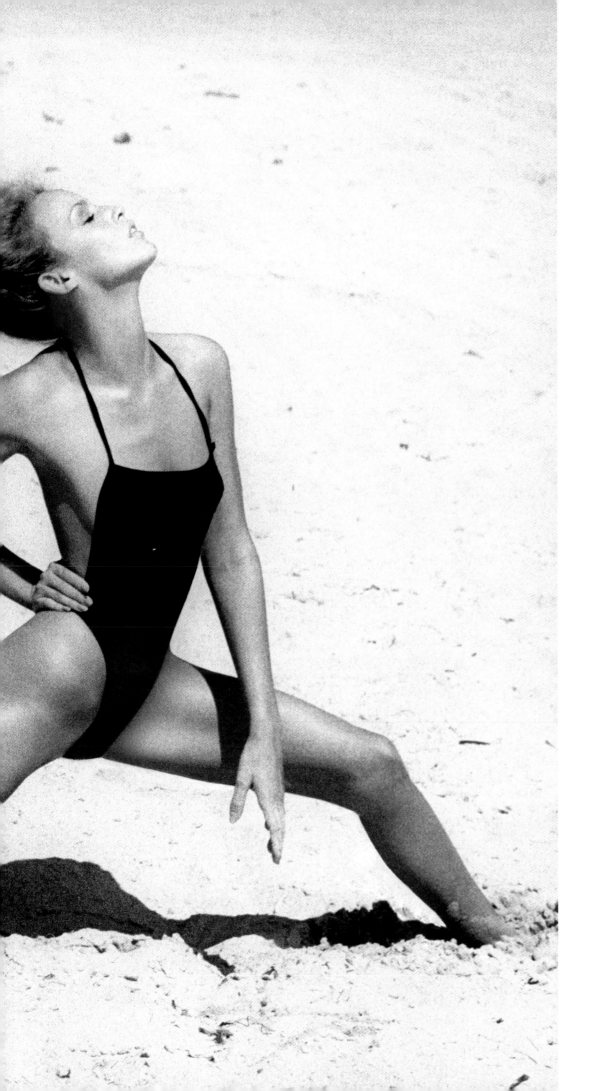

HELMUT NEWTON,
Lisa Taylor and Jerry Hall, January 1975.

IRVING PENN, *Gisele*, July 1999.

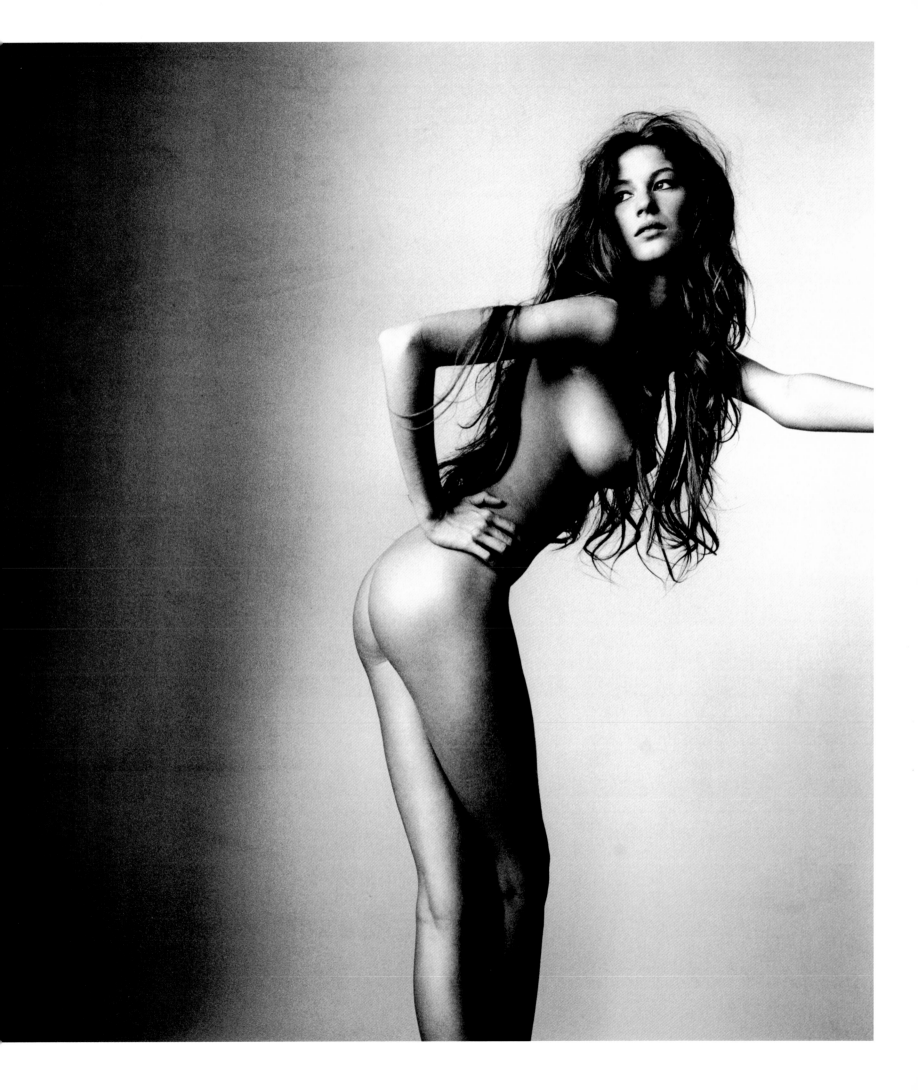

IRVING PENN, *Kate Moss*, September 1996.

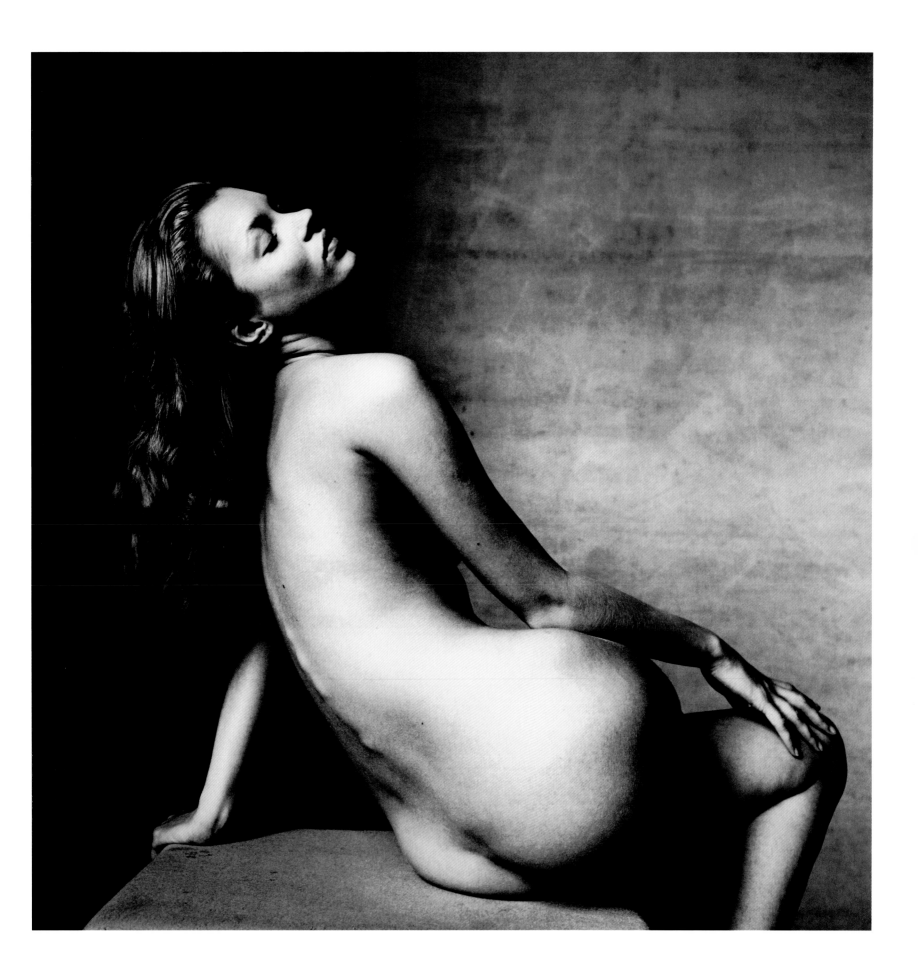

EDWARD STEICHEN, *"Beauty Primer" Your Hands*, June 1934.

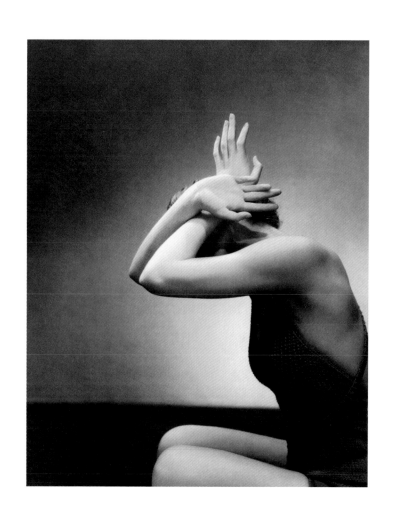

ELLEN VON UNWERTH, *Drew Barrymore Stretching*, June 1993.

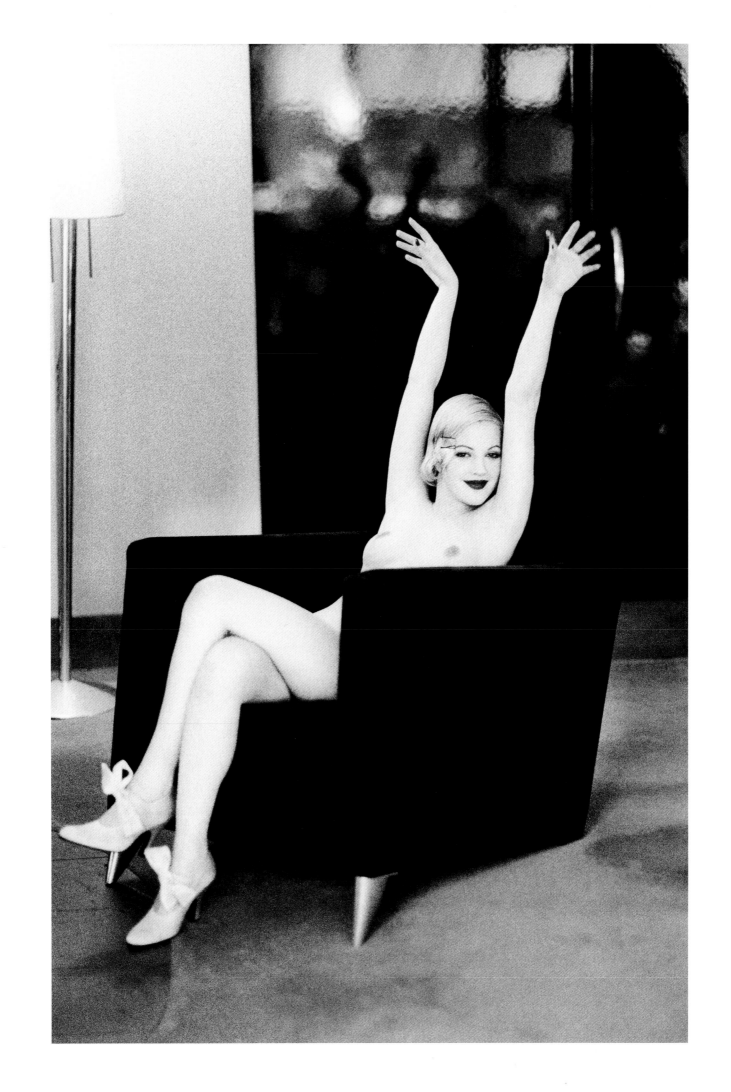

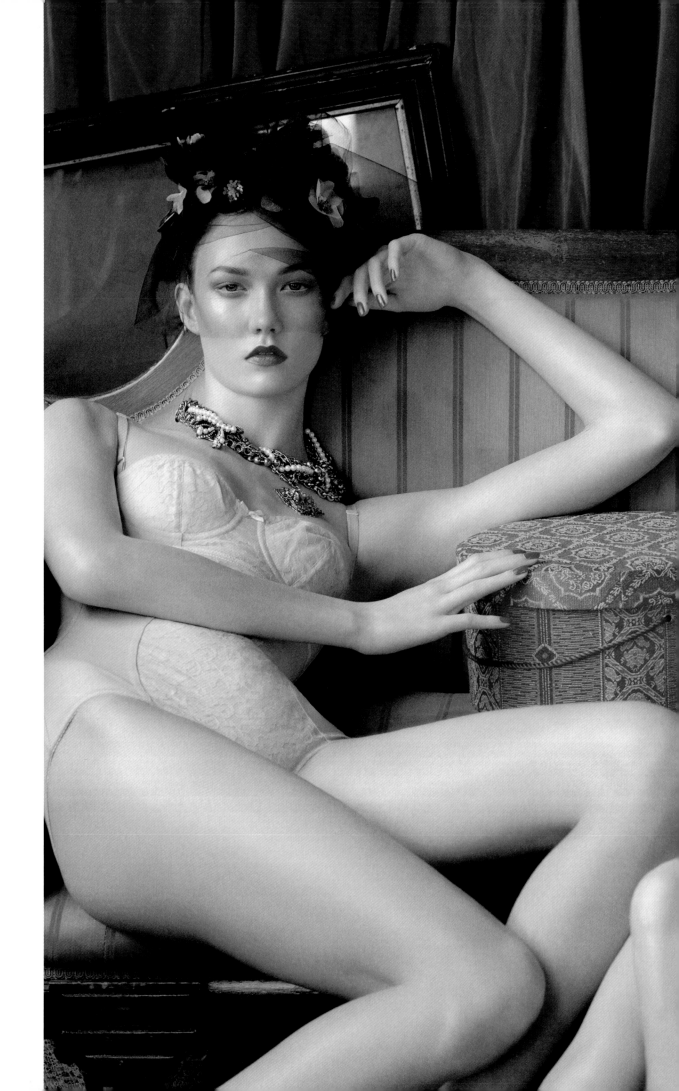

STEVEN MEISEL, *Untitled*,
February 2009.

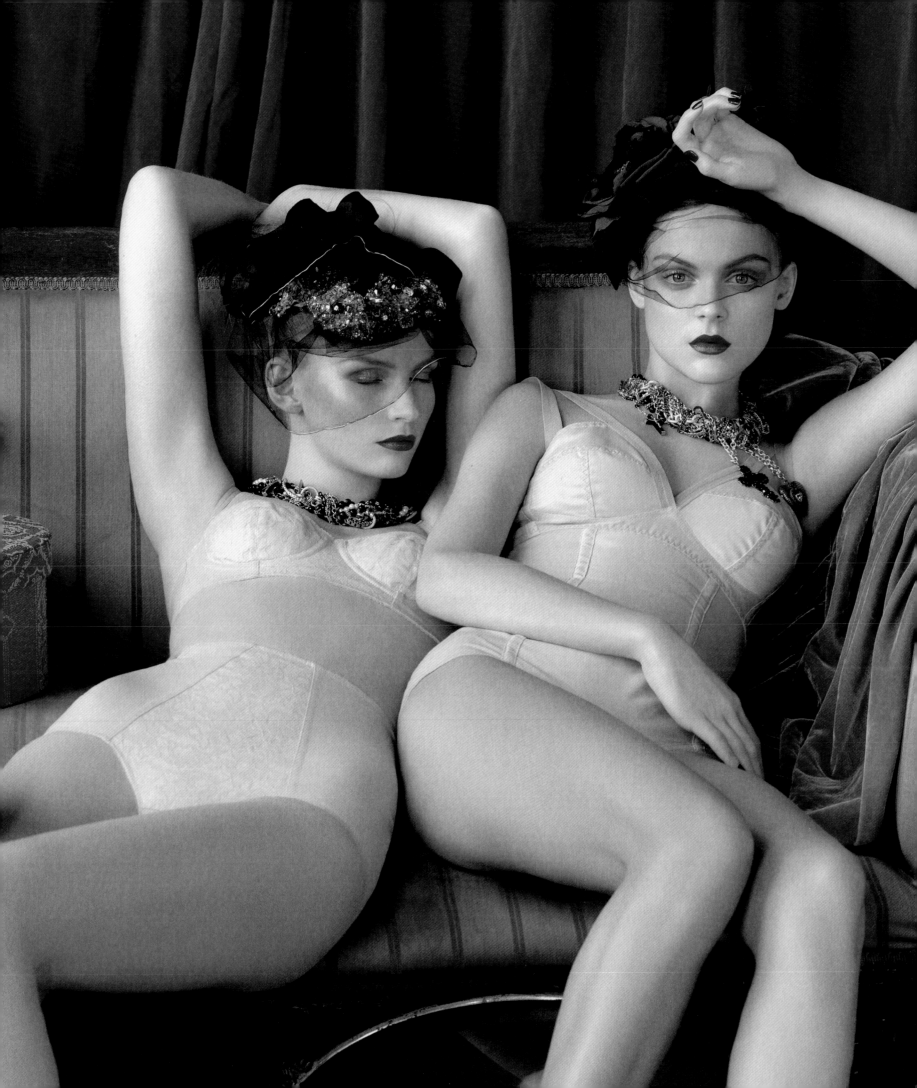

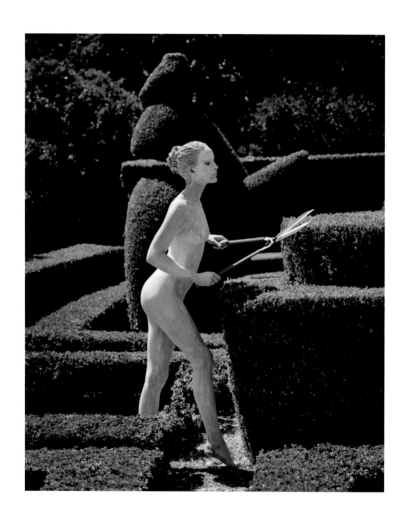

HERB RITTS, *Beach and Beyond, Body Sculpting (A)*, June 1996.
RIGHT: HERB RITTS, *Beach and Beyond, Body Sculpting (B)*, June 1996.

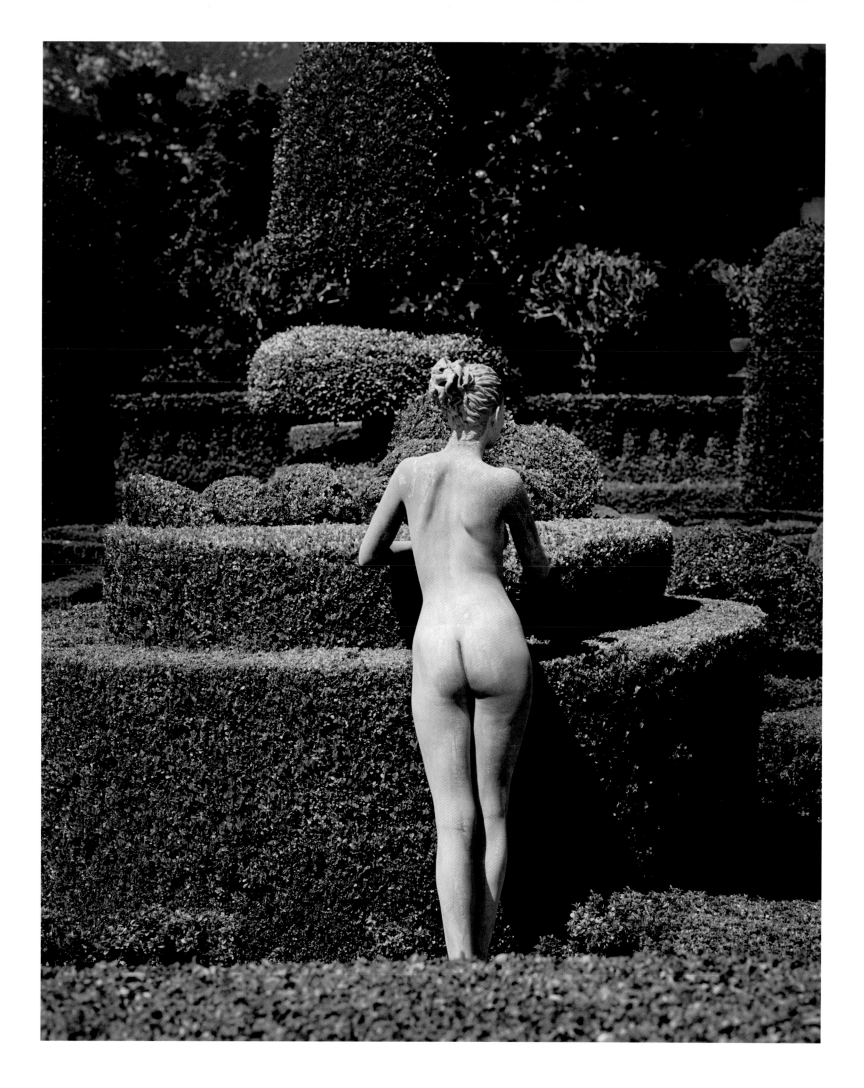

HEADS

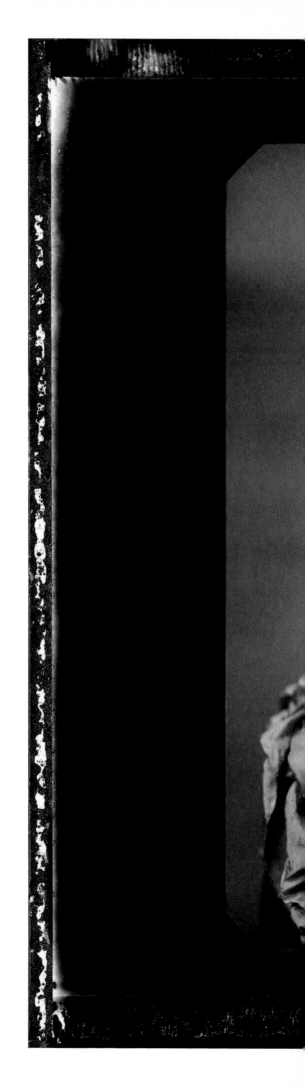

ANNIE LEIBOVITZ, *Kate Moss*, October 1999.

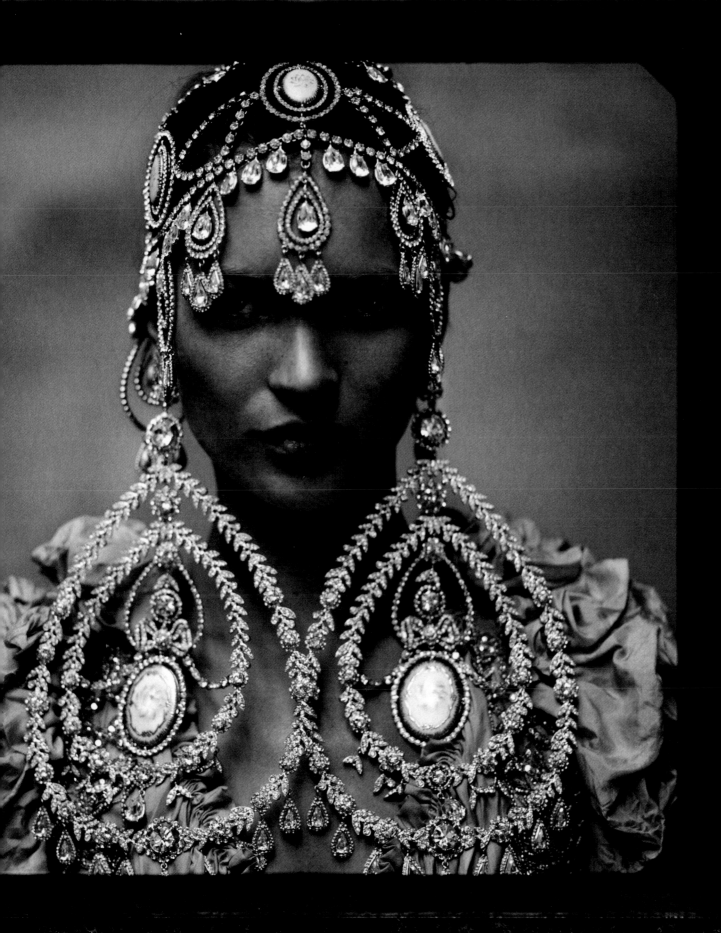

STEVEN MEISEL, *Untitled*, September 2007.

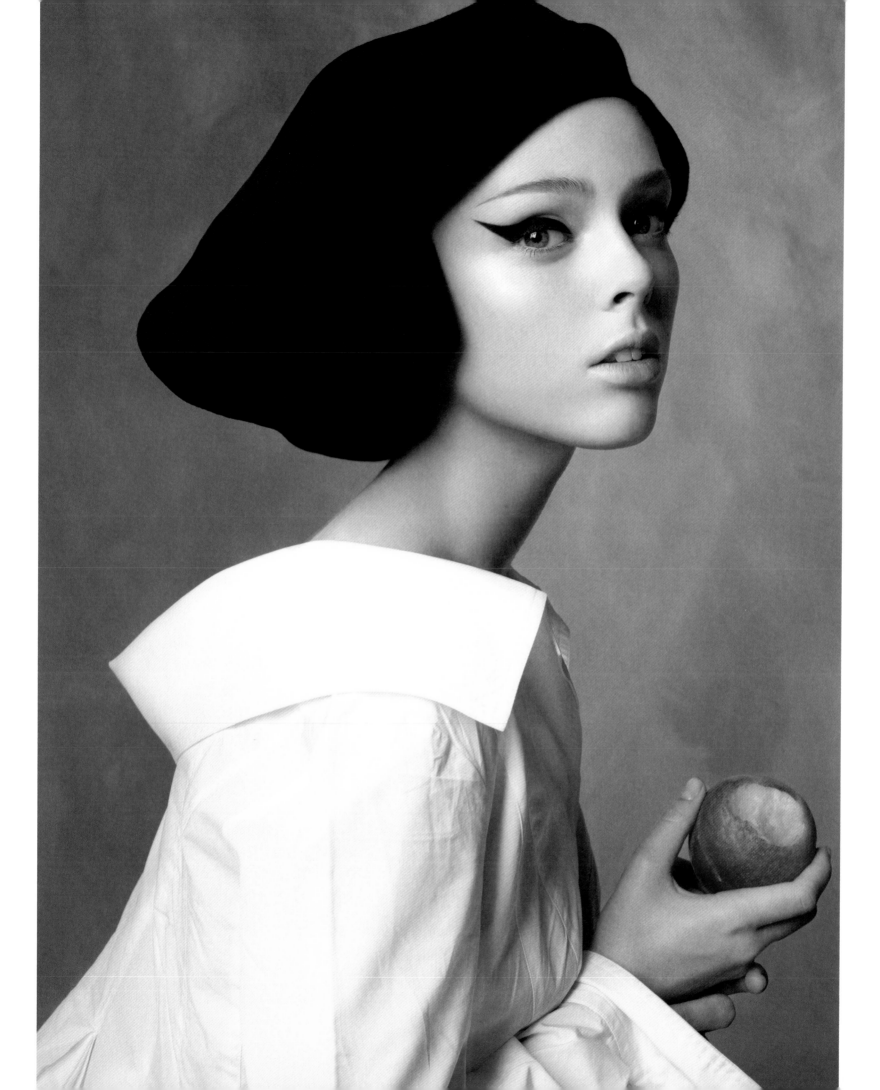

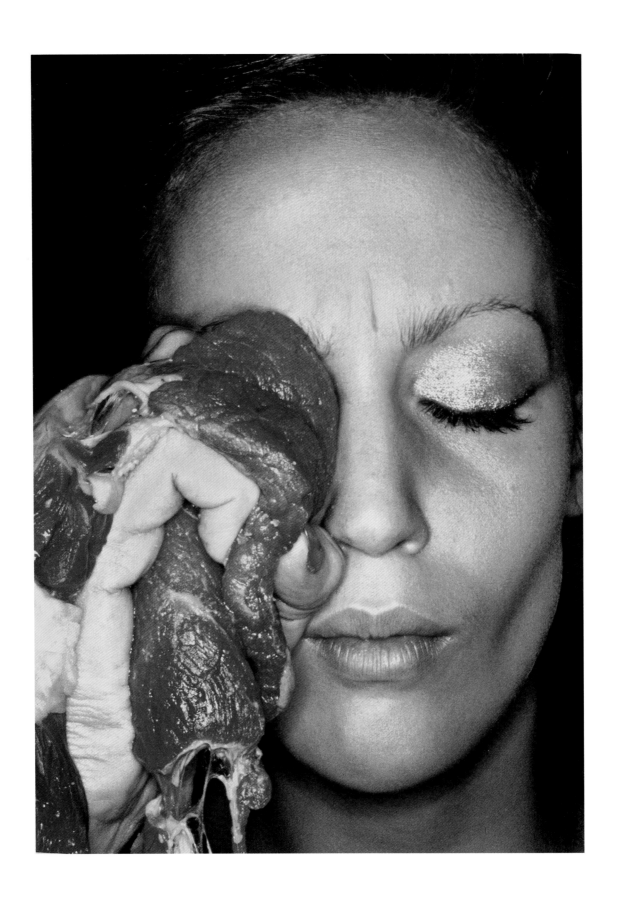

HELMUT NEWTON, *A Cure for the Black Eye*, October 1974,
© 2009 The Helmut Newton Estate/Maconochie Photography.

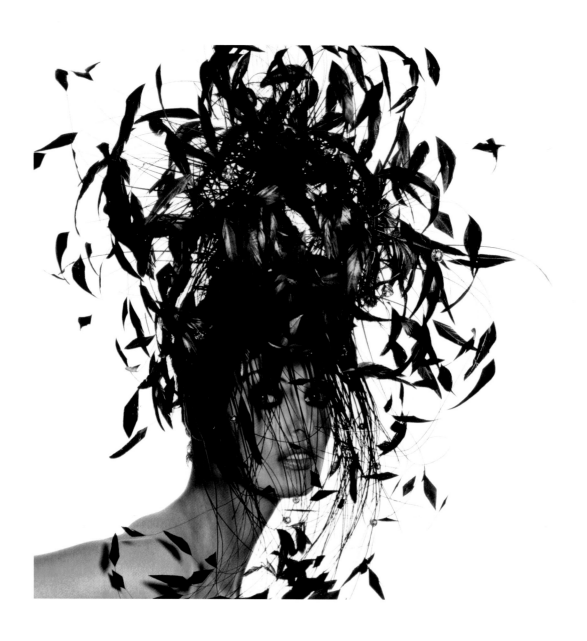

IRVING PENN, *Woman in Feather Hat (C)*, January 1991.
RIGHT: IRVING PENN, *Nadja in Feather Mask*, December 1994.

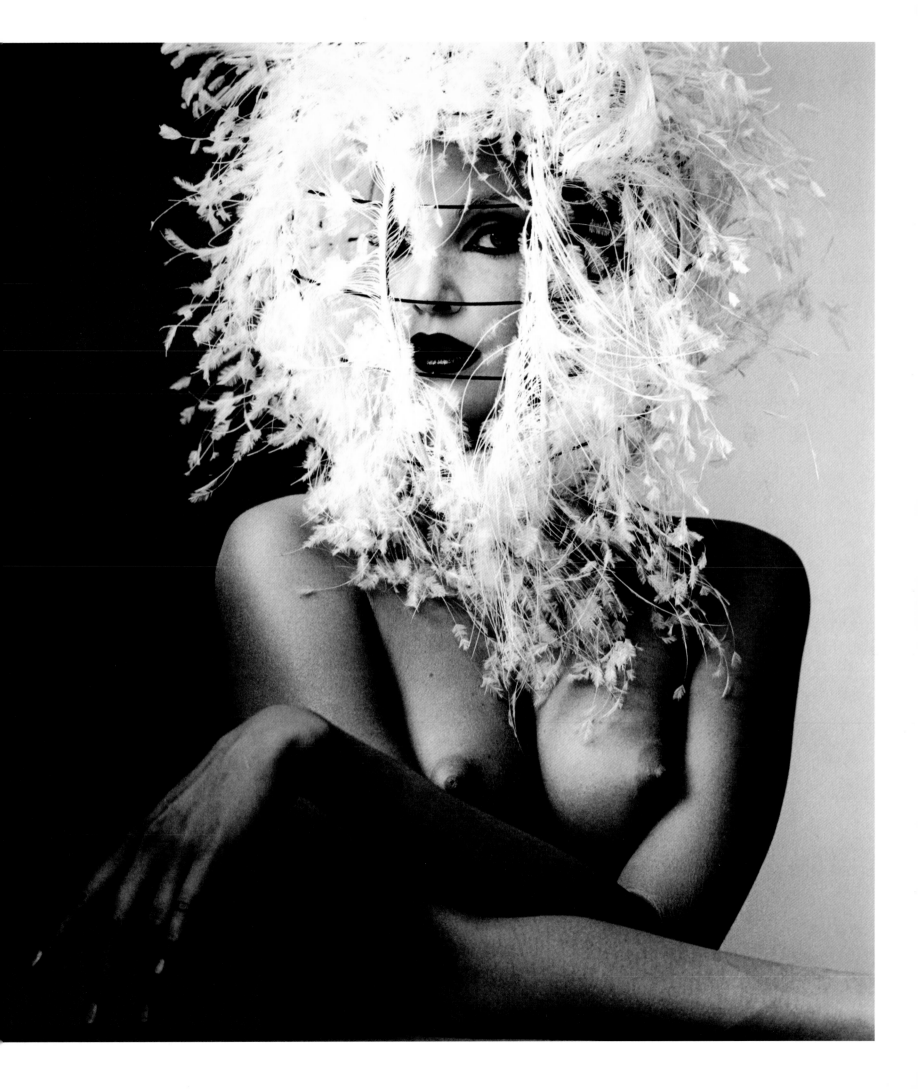

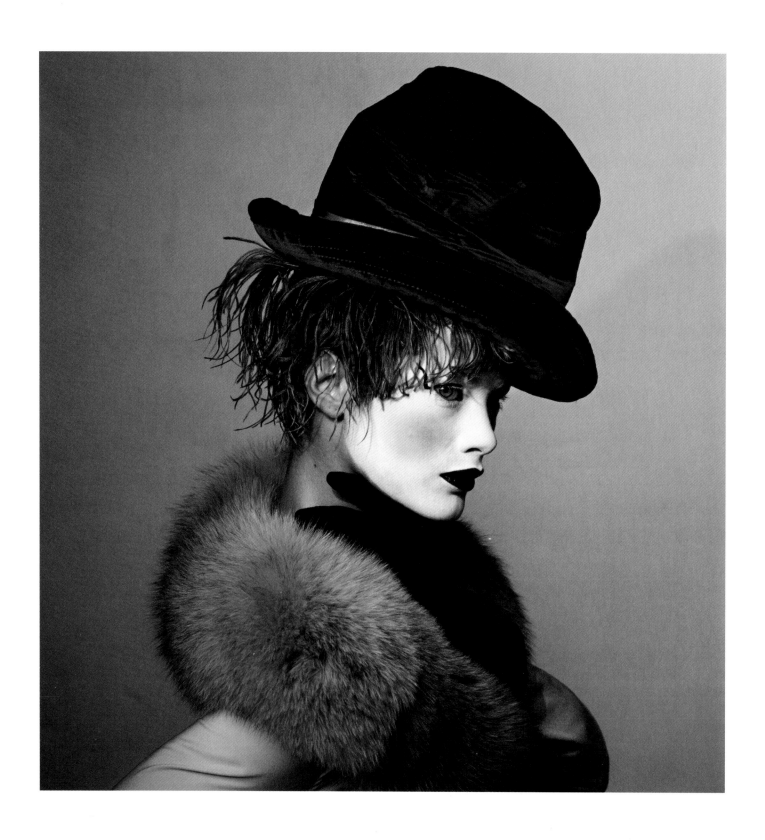

IRVING PENN, *Hat Trick*, July 2007.

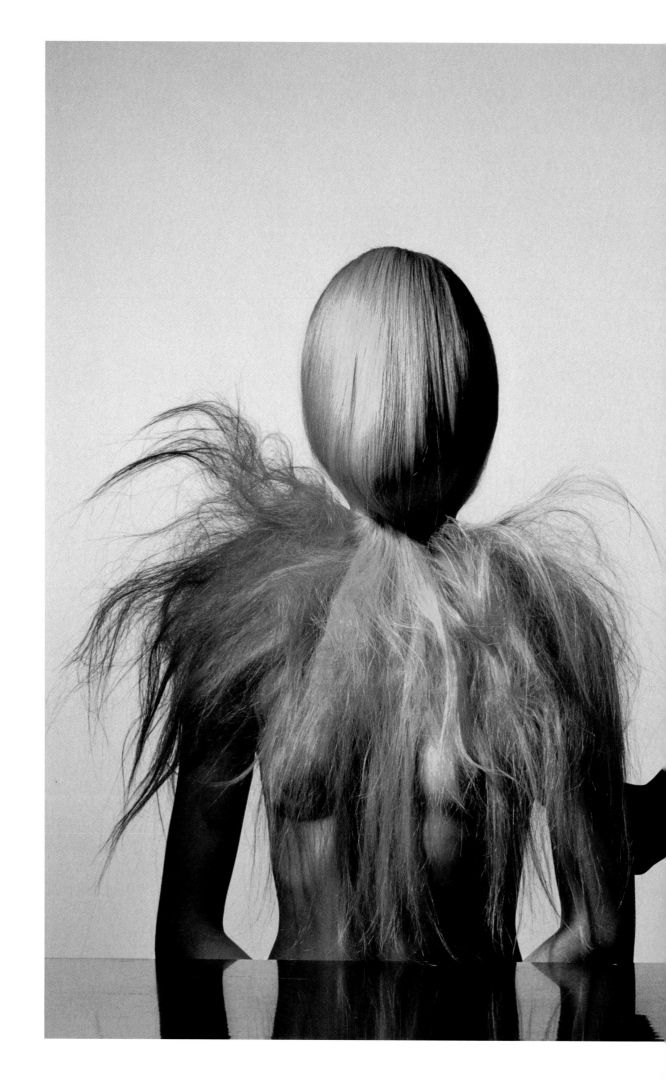

IRVING PENN,
Two Hairy Young Women, July 1995.

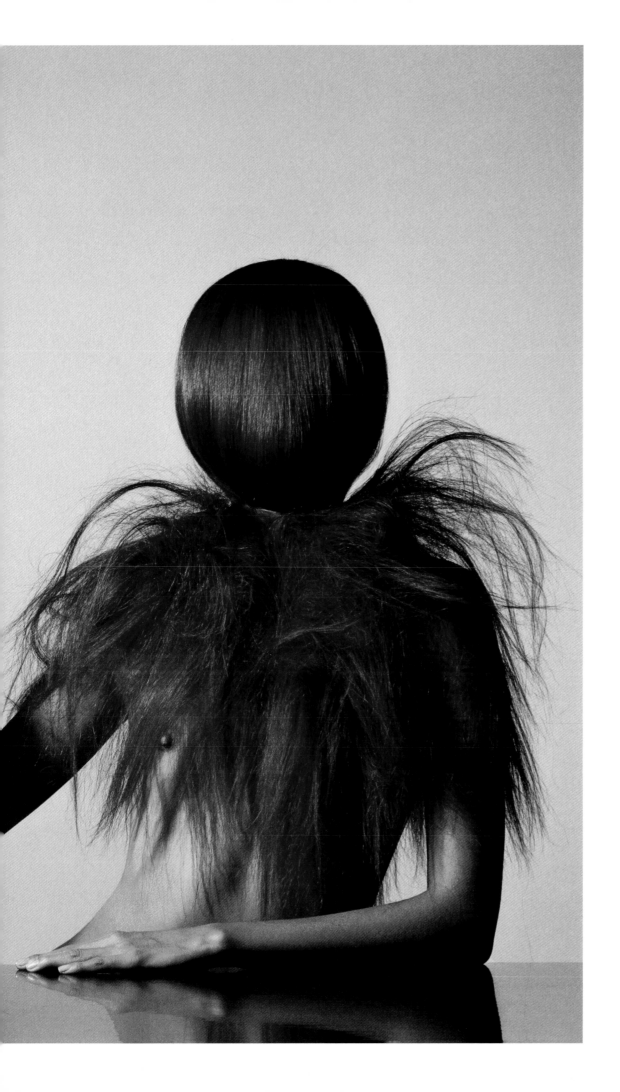

ANNIE LEIBOVITZ, *Venus Williams*, May 1998.

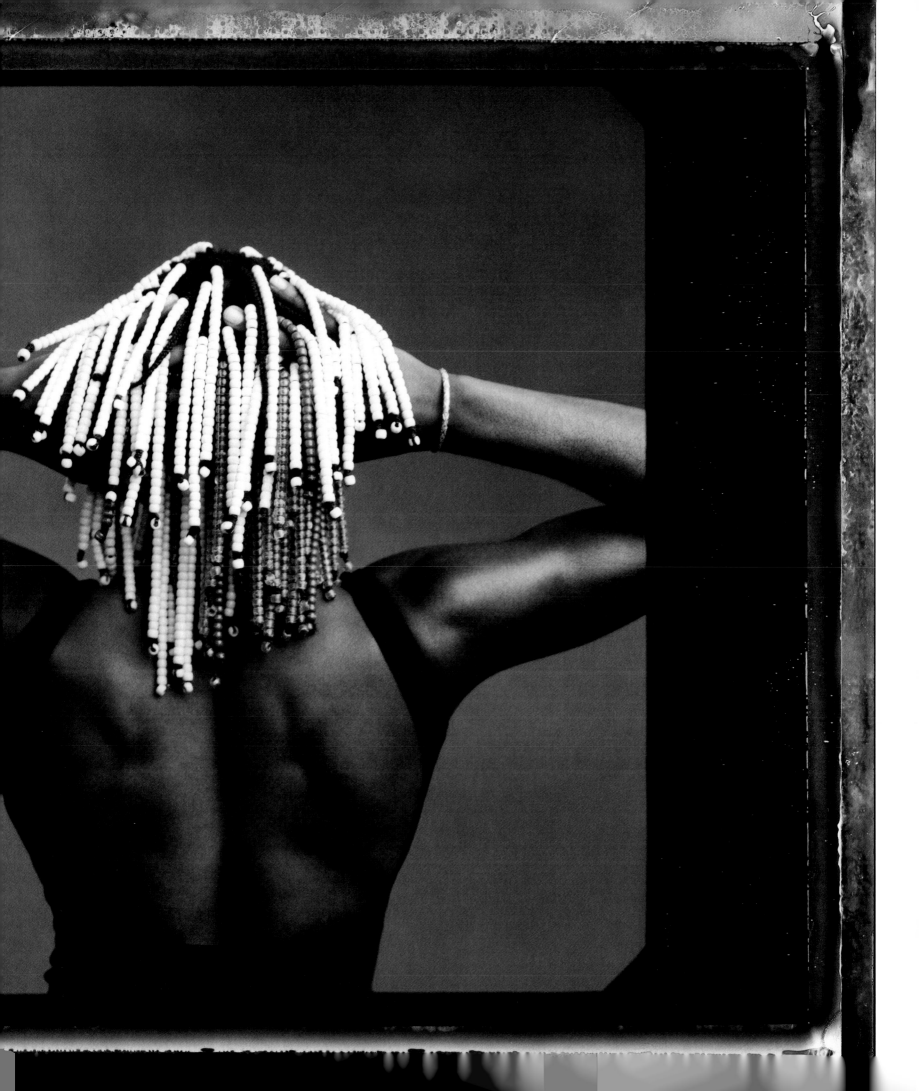

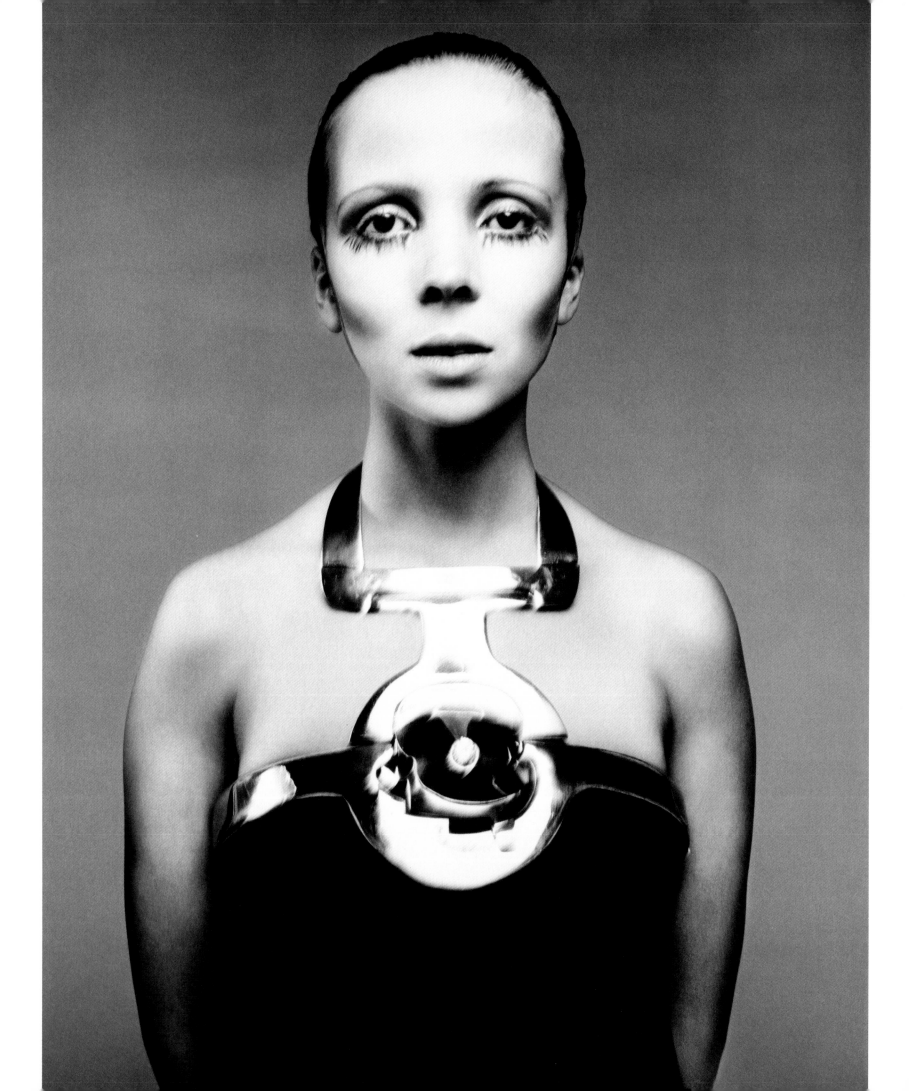

BRUCE WEBER, *Talisa Soto, Miami, Florida*, June 1989.

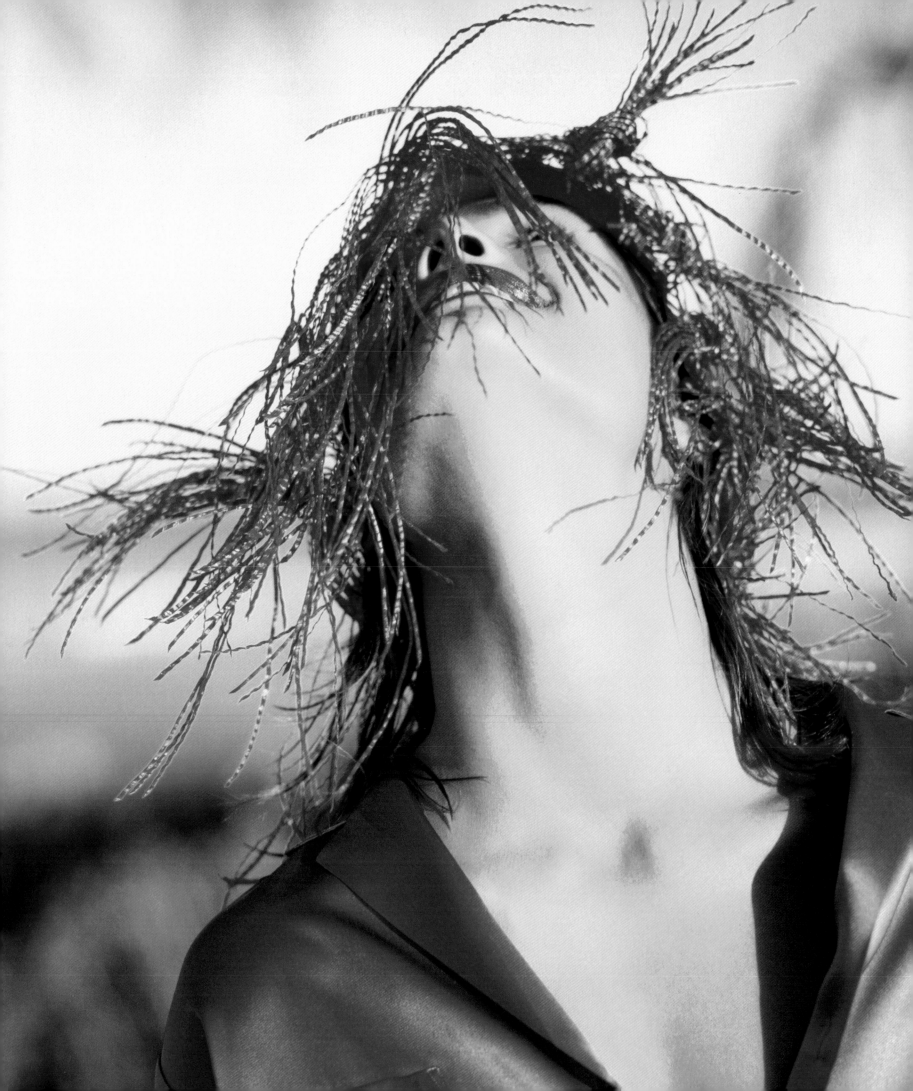

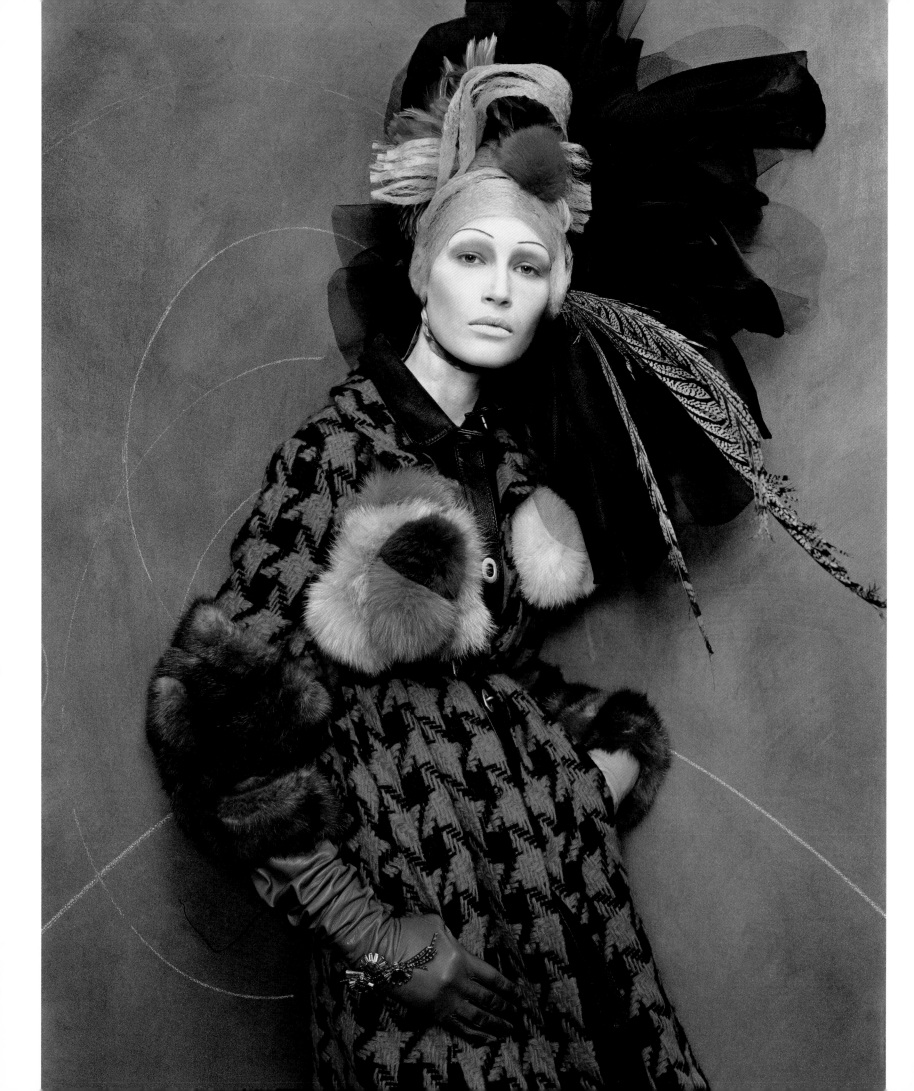

STEVEN MEISEL, *Untitled*, October 2003.

DUANE MICHALS, *Fragrance Your Personal Signal*, May 1979.

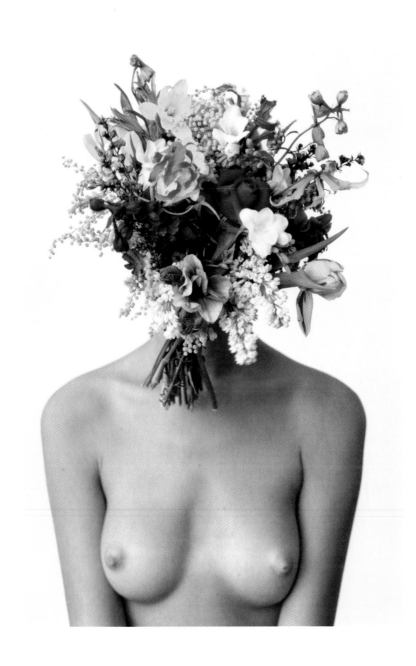

STEVEN MEISEL, *Untitled*, December 2006.

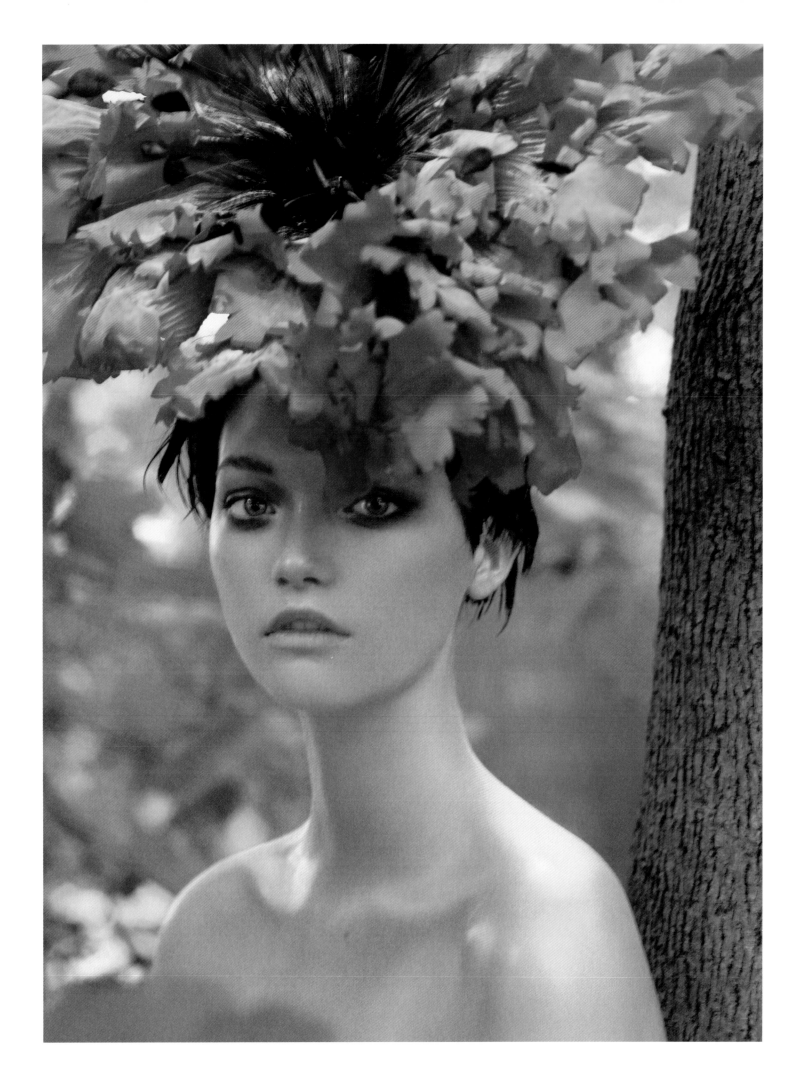

BODIES,
RESTRAINED

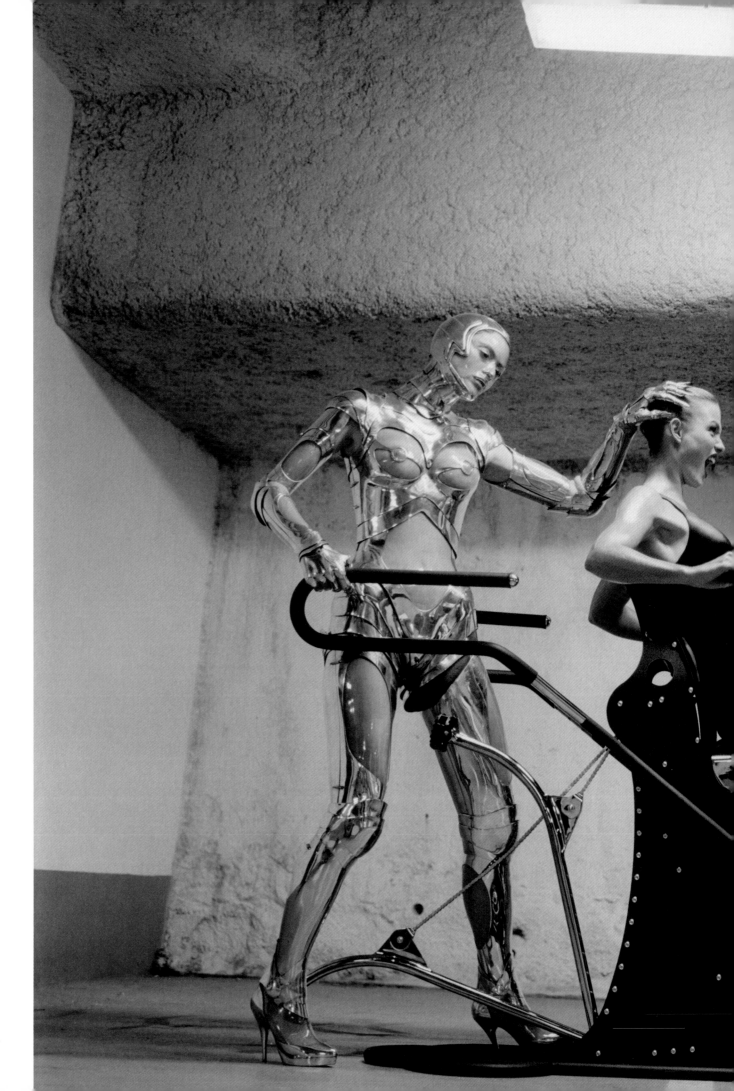

HELMUT NEWTON,
Machine Age,
November 1995,
© 2009 The Helmut Newton
Estate/Maconochie Photography.

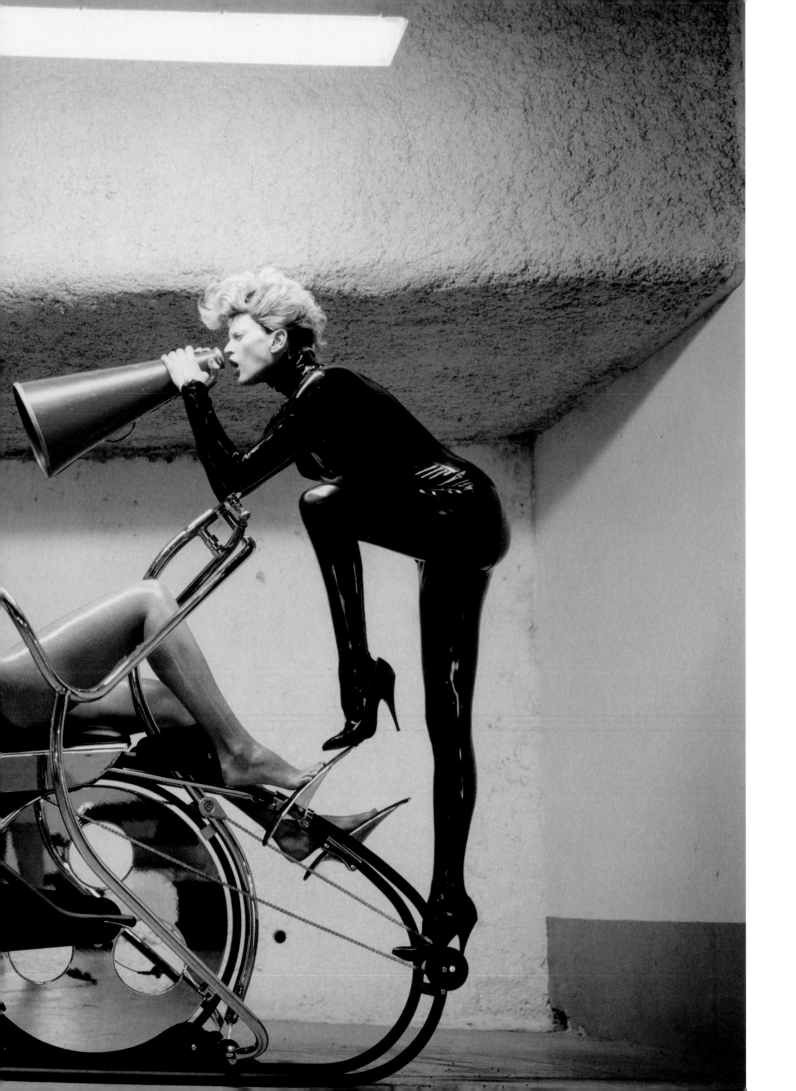

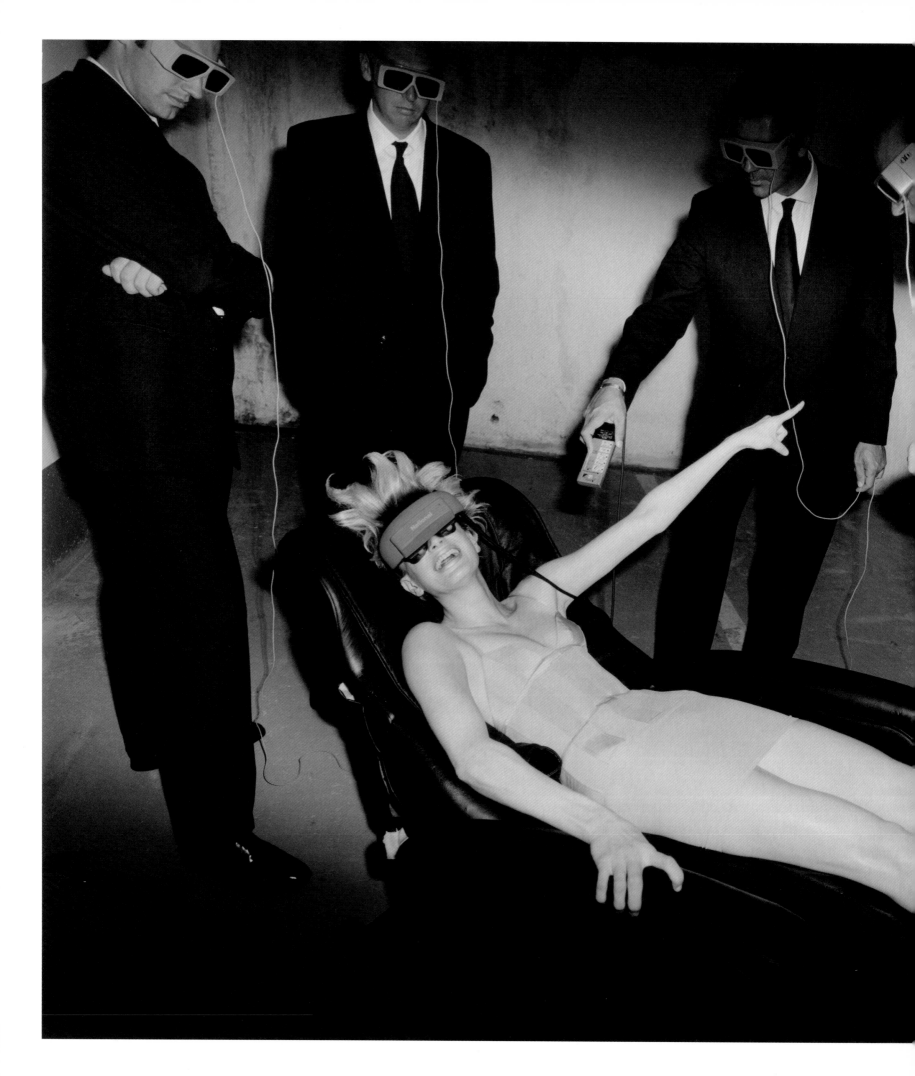

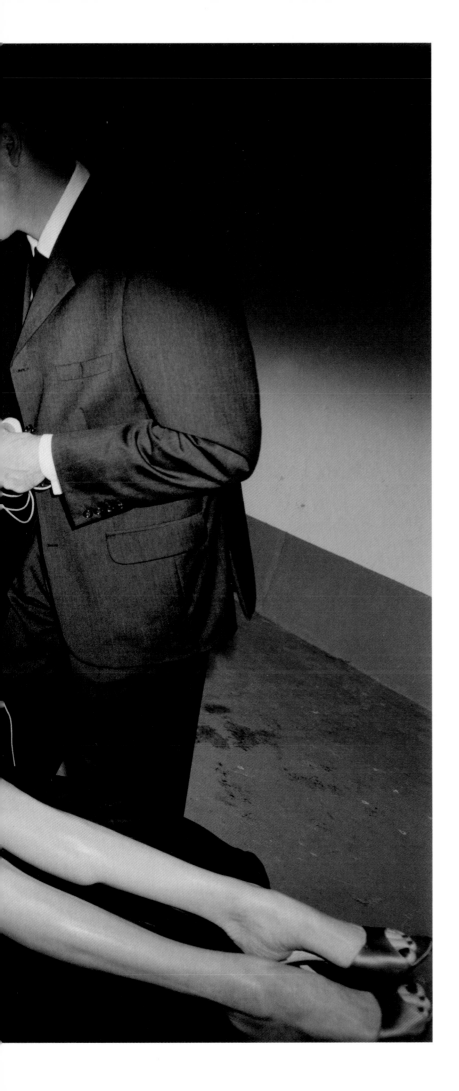

HELMUT NEWTON, *Machine Age*, November 1995,
© 2009 The Helmut Newton Estate/Maconochie Photography.

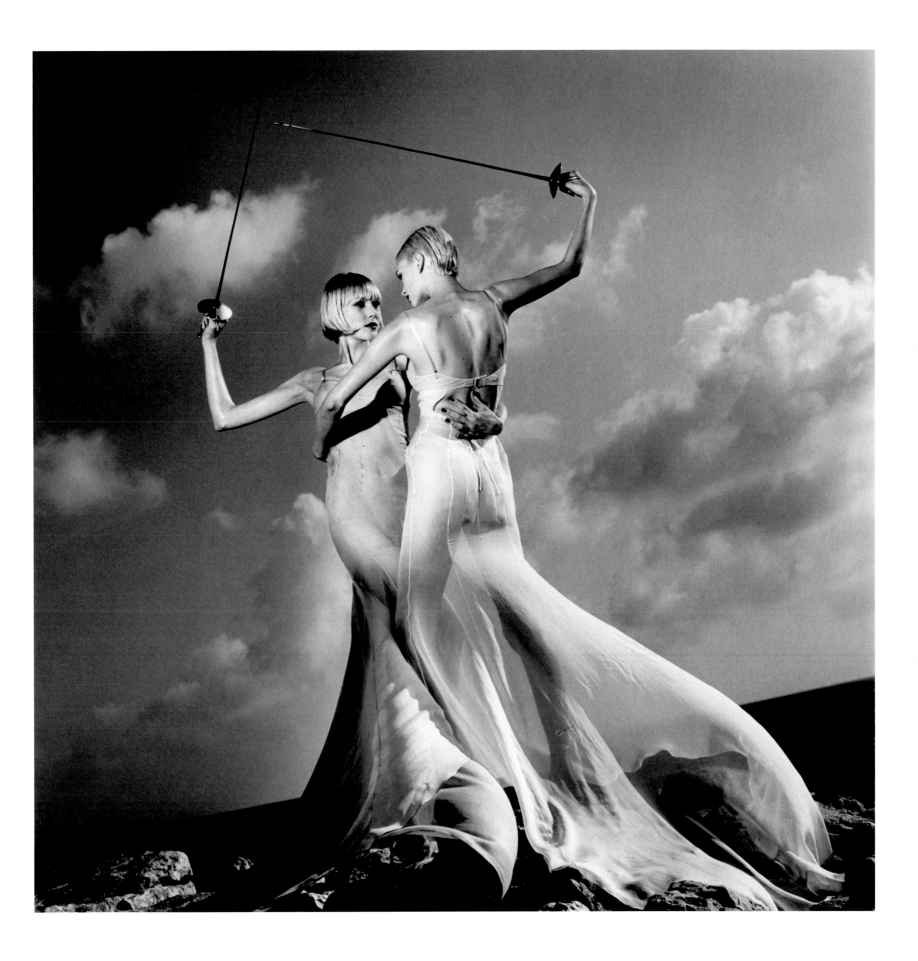

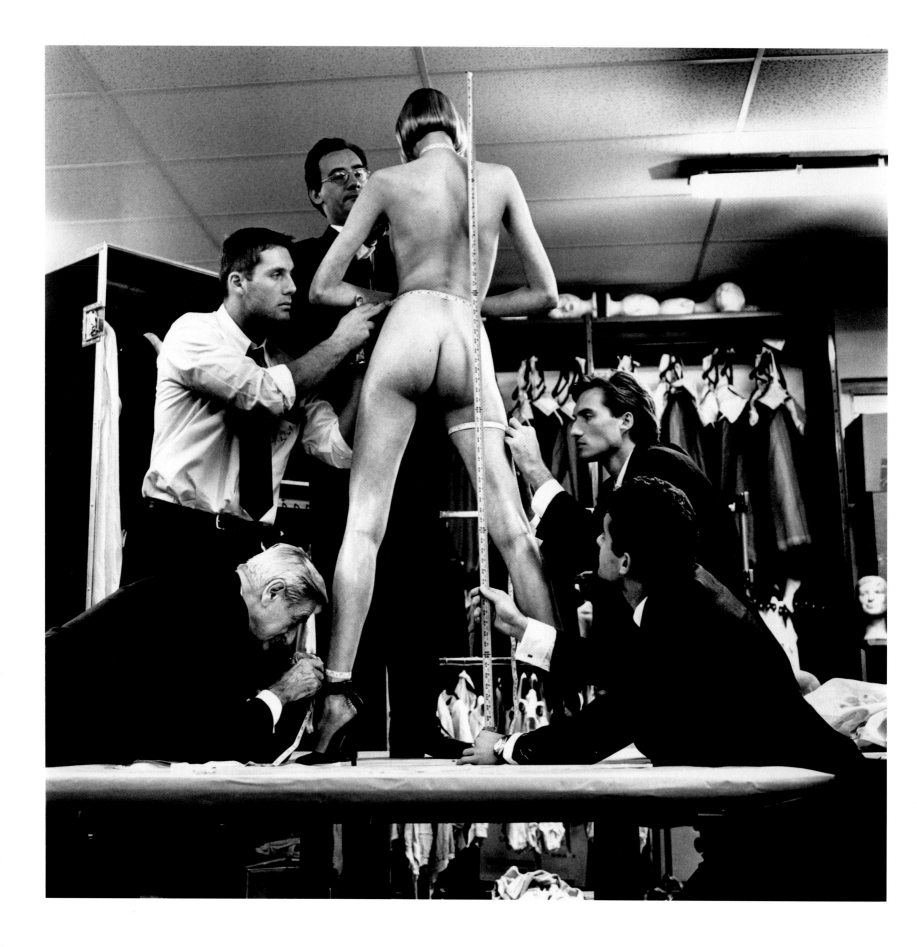

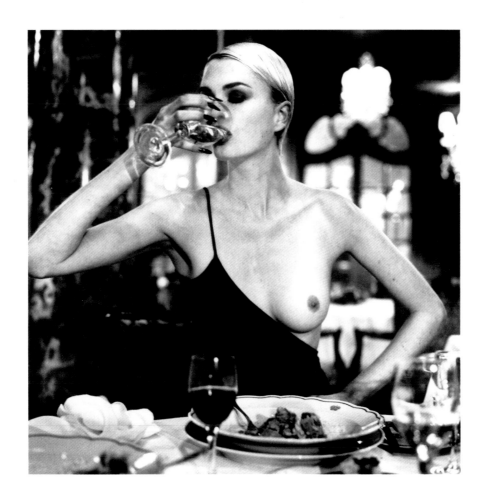

LEFT: HELMUT NEWTON, *Measuring for Perfection*, January 1997.
HELMUT NEWTON, *Naked Lunch*, May 1997,
© 2009 The Helmut Newton Estate/Maconochie Photography.

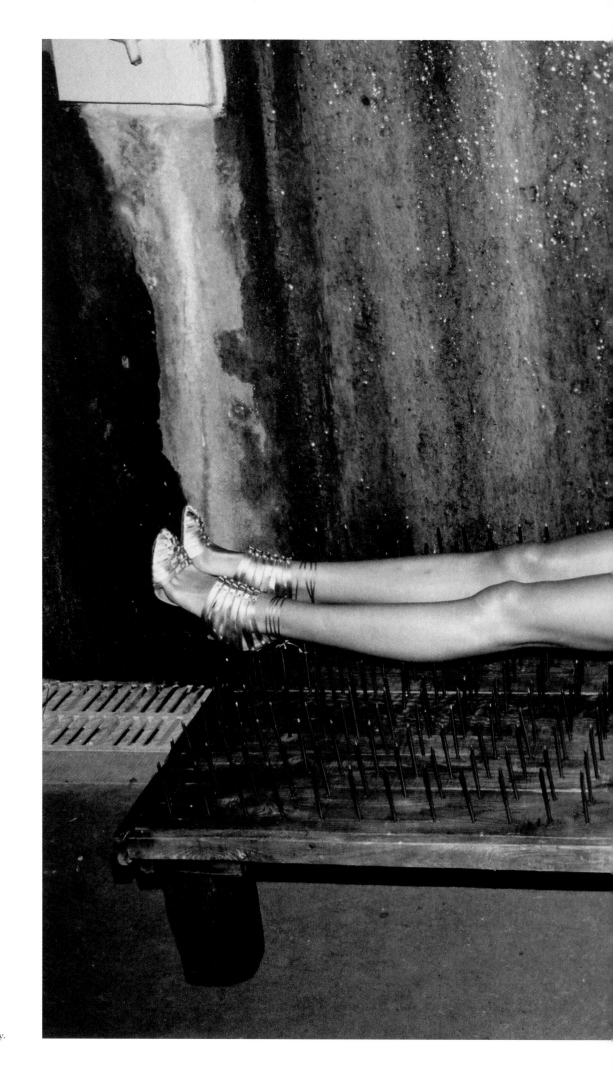

HELMUT NEWTON, *Bed of Nails*,
March 2004,
© 2009 The Helmut Newton Estate/Maconochie Photography.

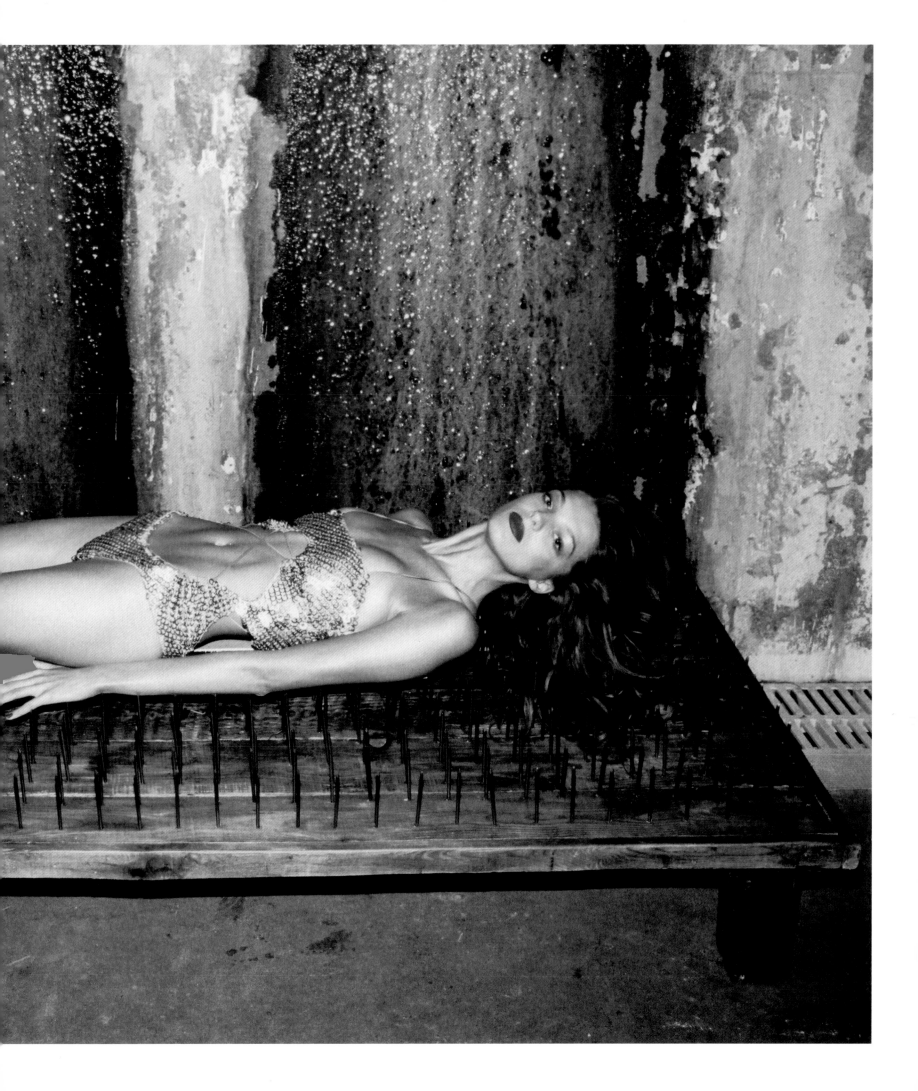

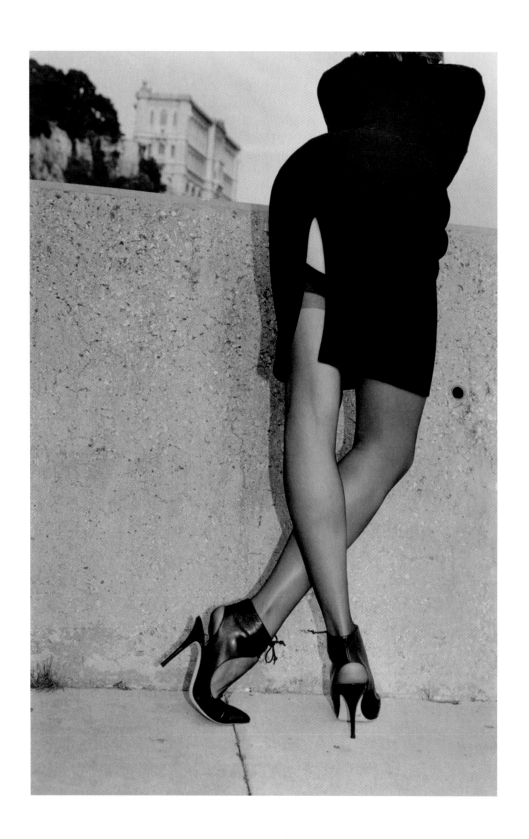

HELMUT NEWTON, *Monte Carlo,* February 1995.
RIGHT: HELMUT NEWTON, *High and Mighty,* February 1995,
© 2009 The Helmut Newton Estate/Maconochie Photography.

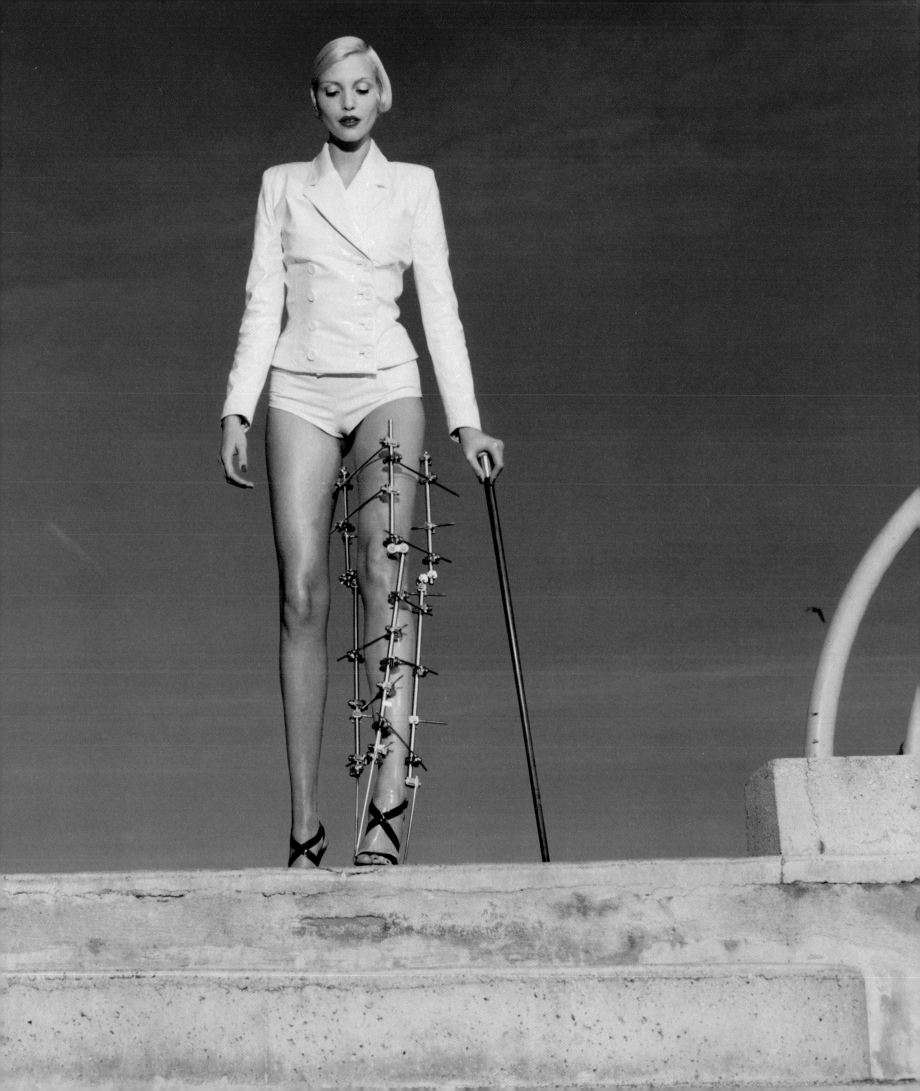

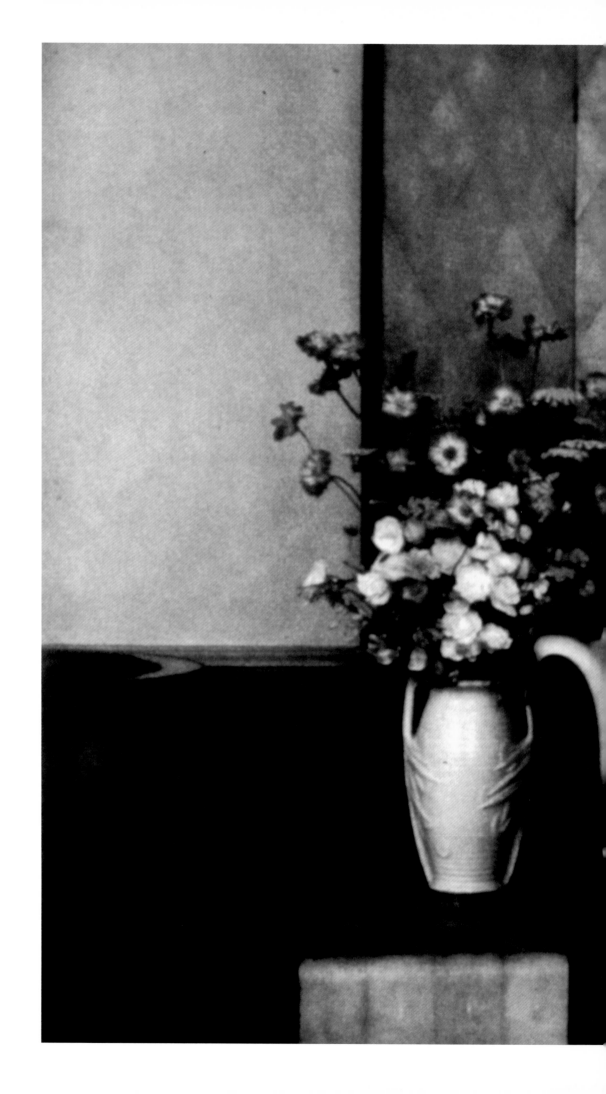

SHEILA METZNER,
Rebecca, Marlo's Flowers,
November 1984.

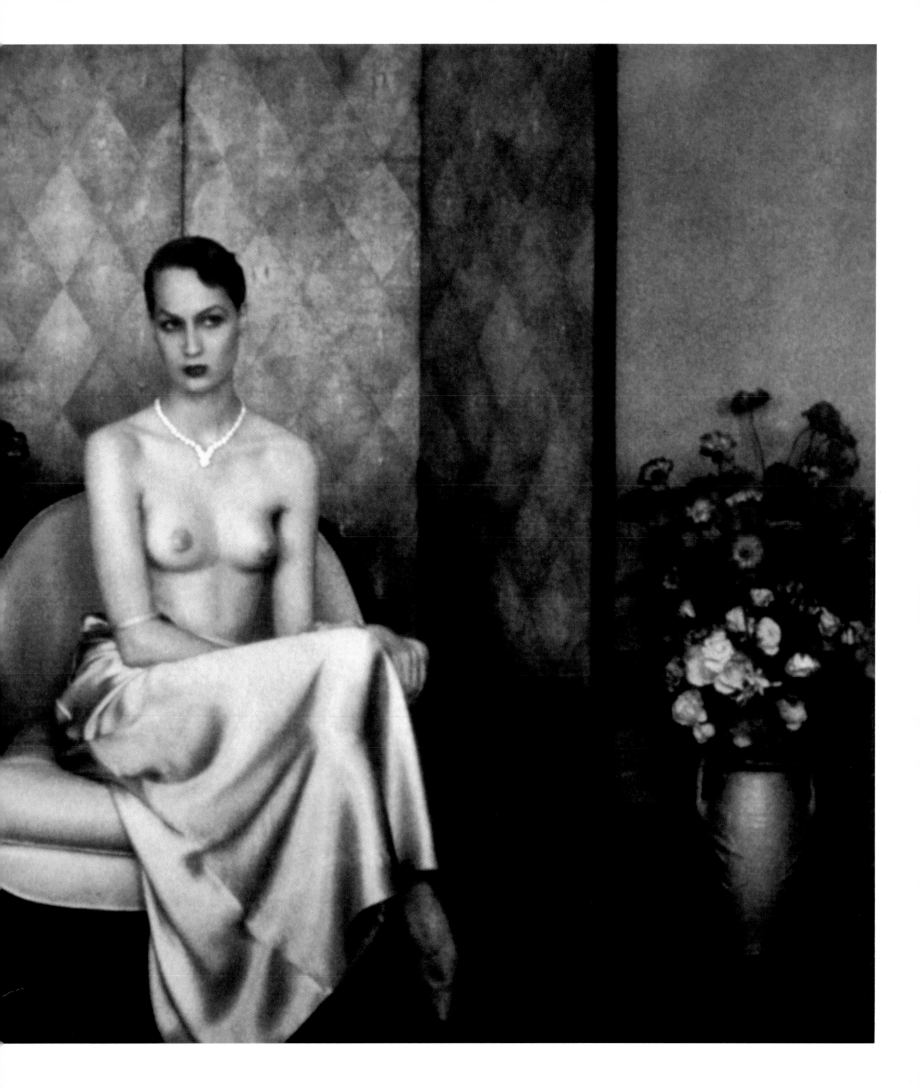

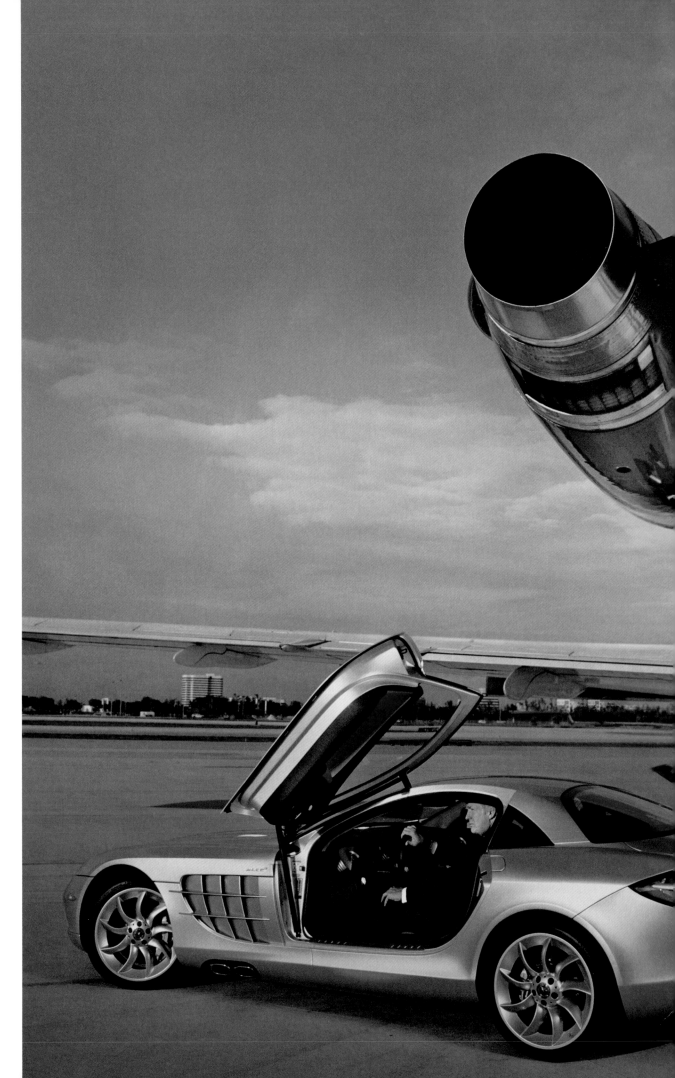

ANNIE LEIBOVITZ,
Donald and Melania Trump,
Palm Beach International Airport, Florida,
April 2006.

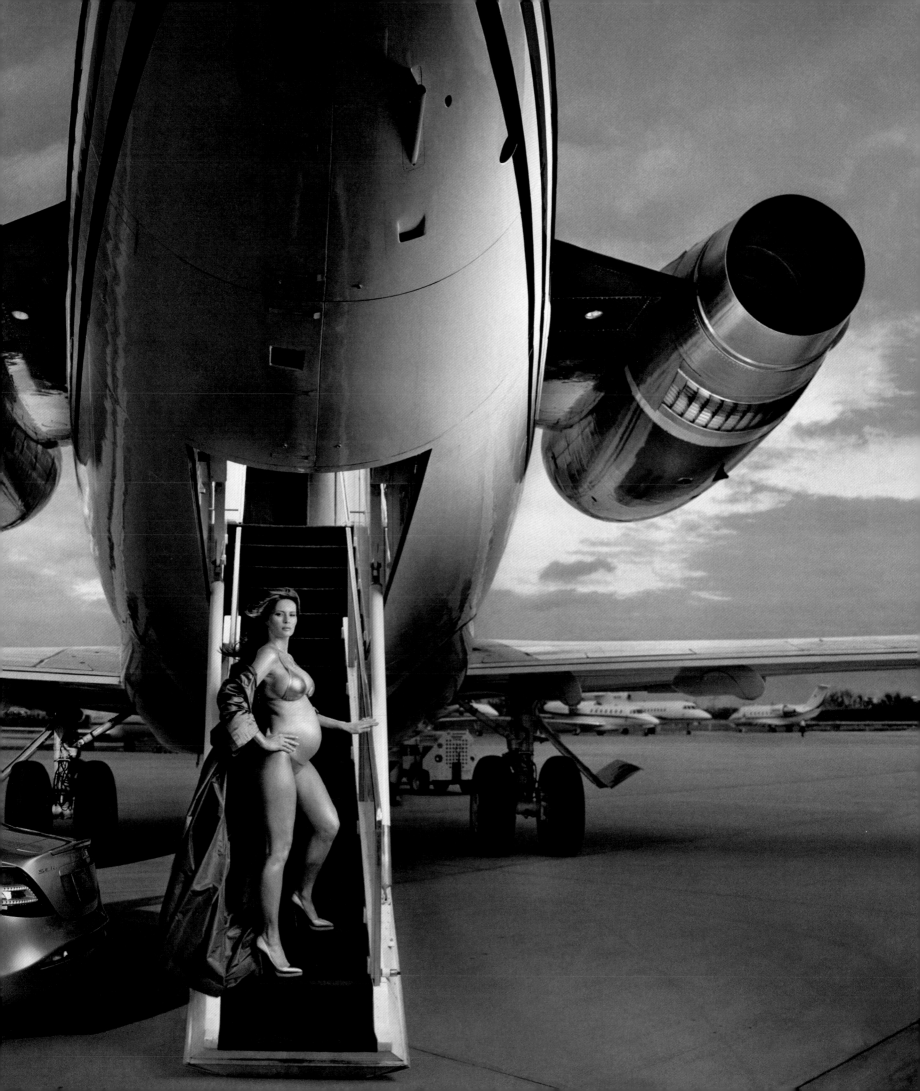

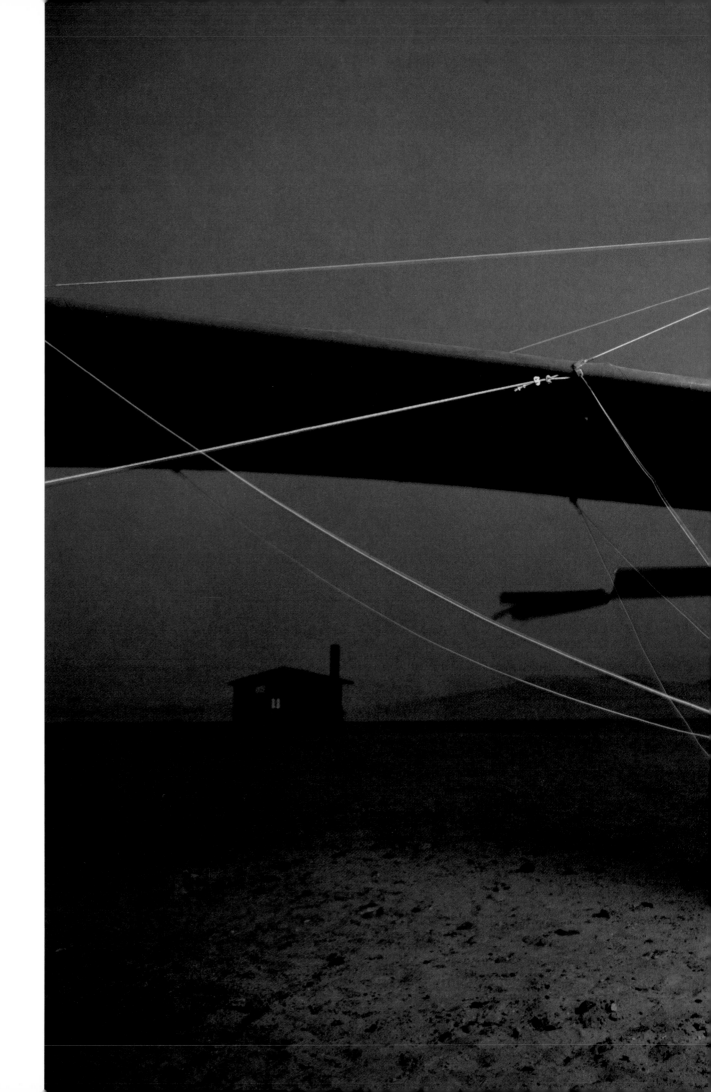

ANNIE LEIBOVITZ,
Angelina Jolie, January 2007.

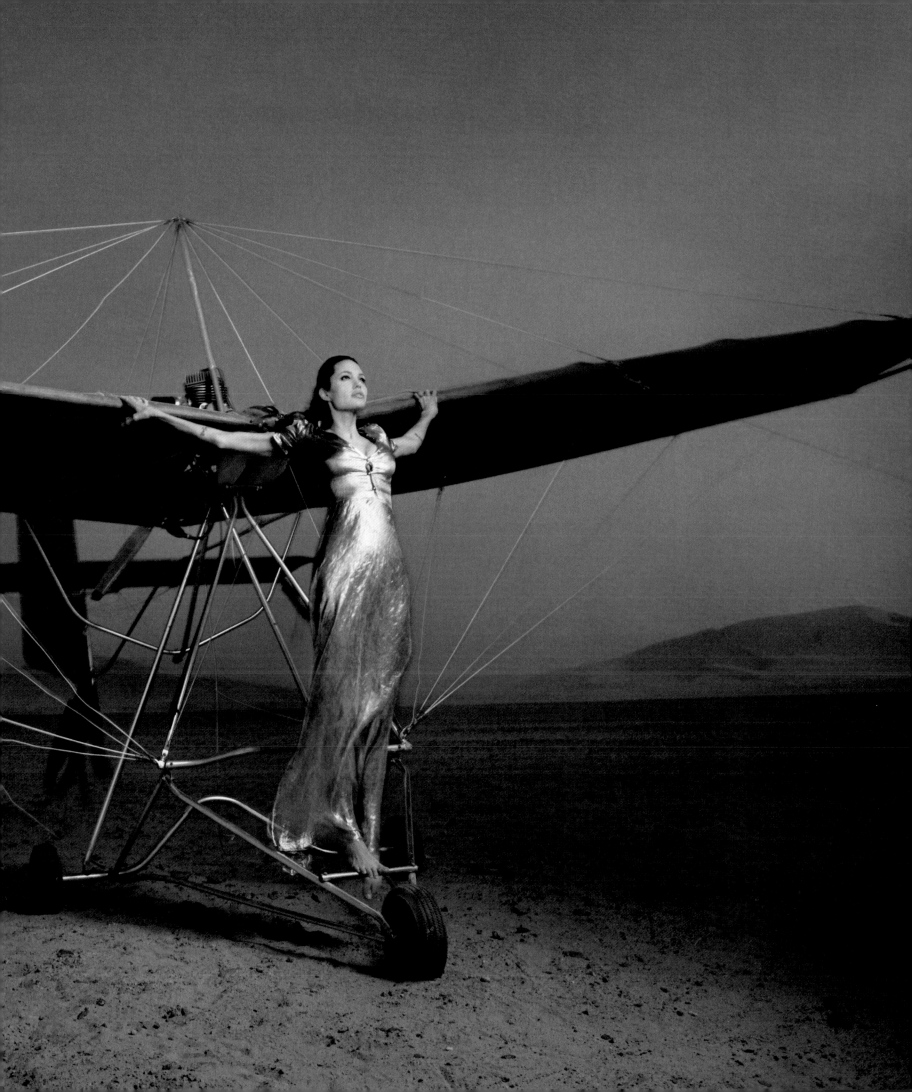

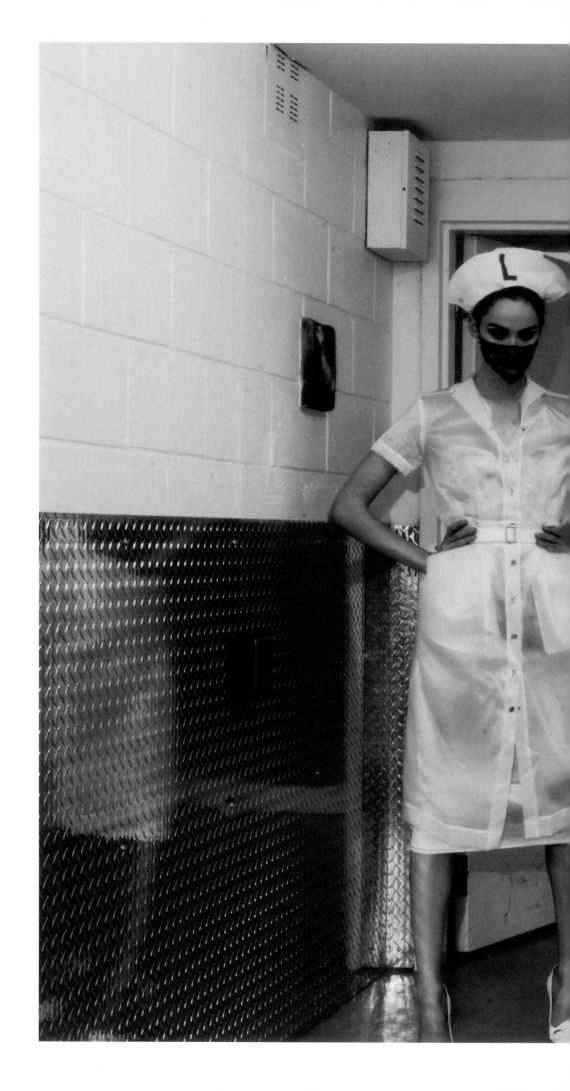

STEVEN KLEIN,
Medical Mistakes, May 2008.

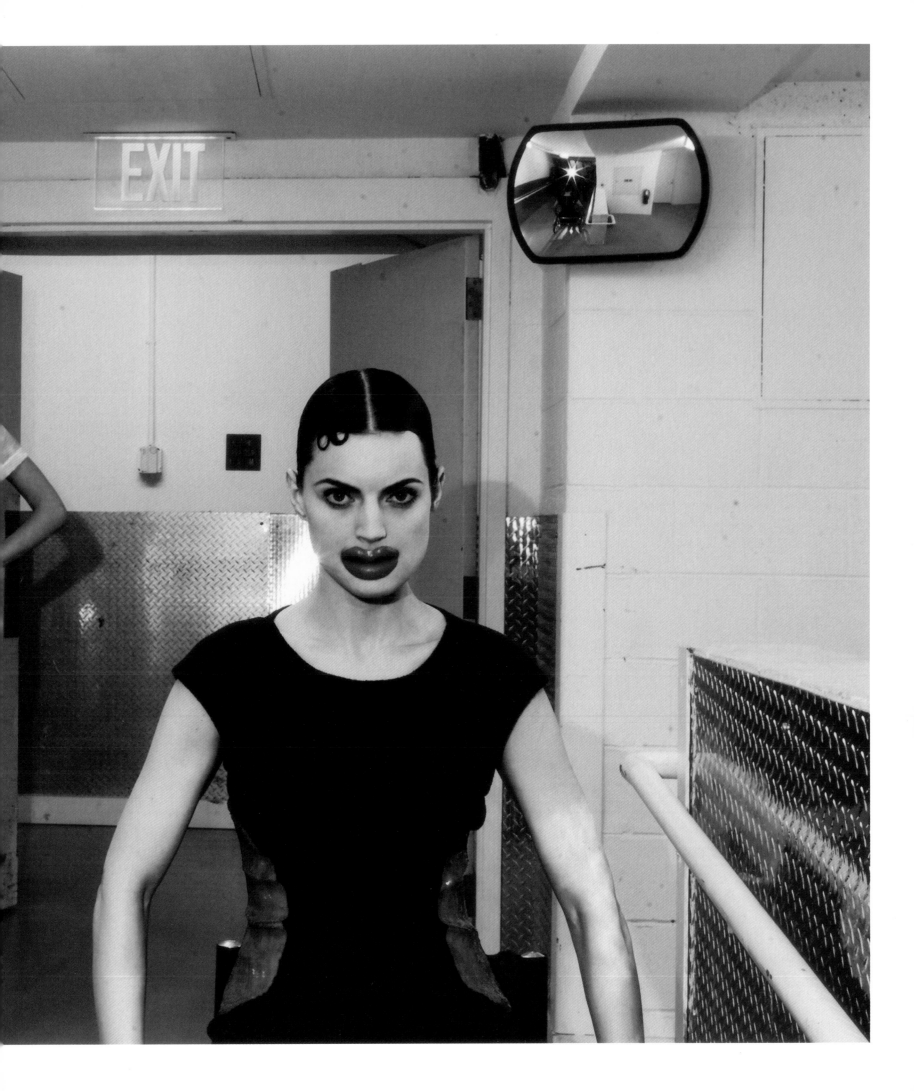

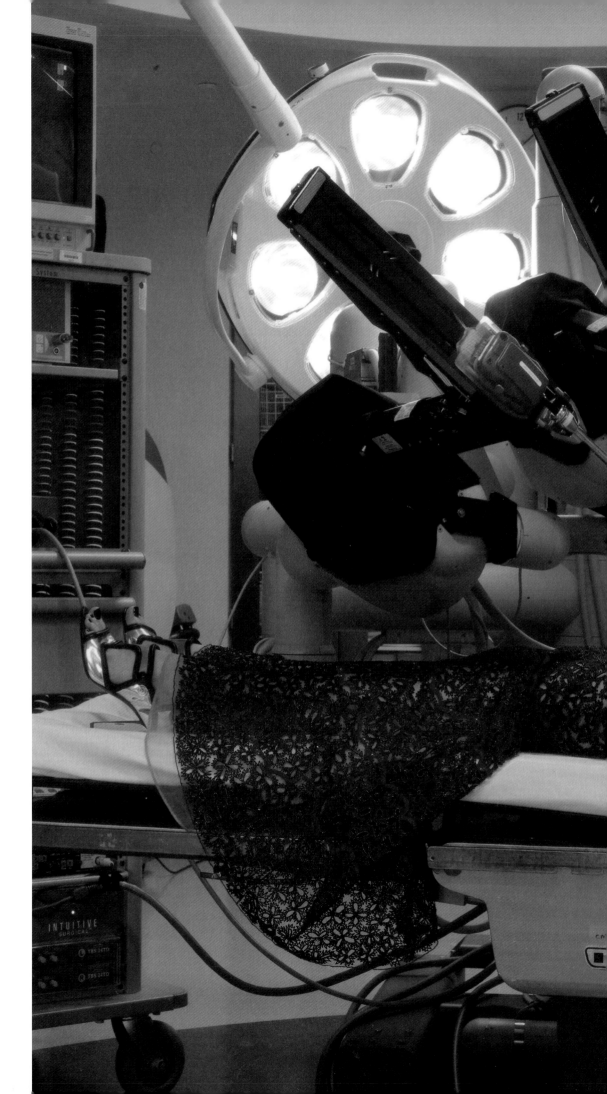

STEVEN KLEIN,
Intelligent Designs—Remote Control, January 2006.

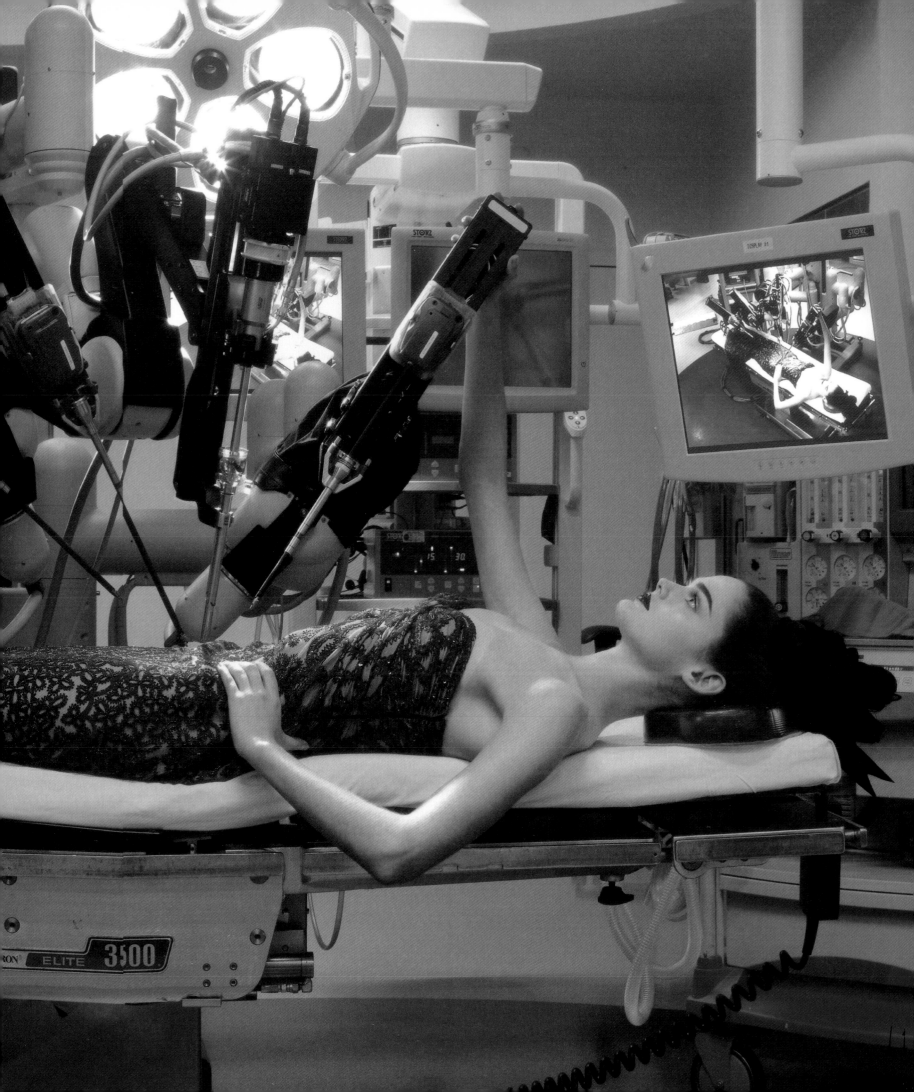

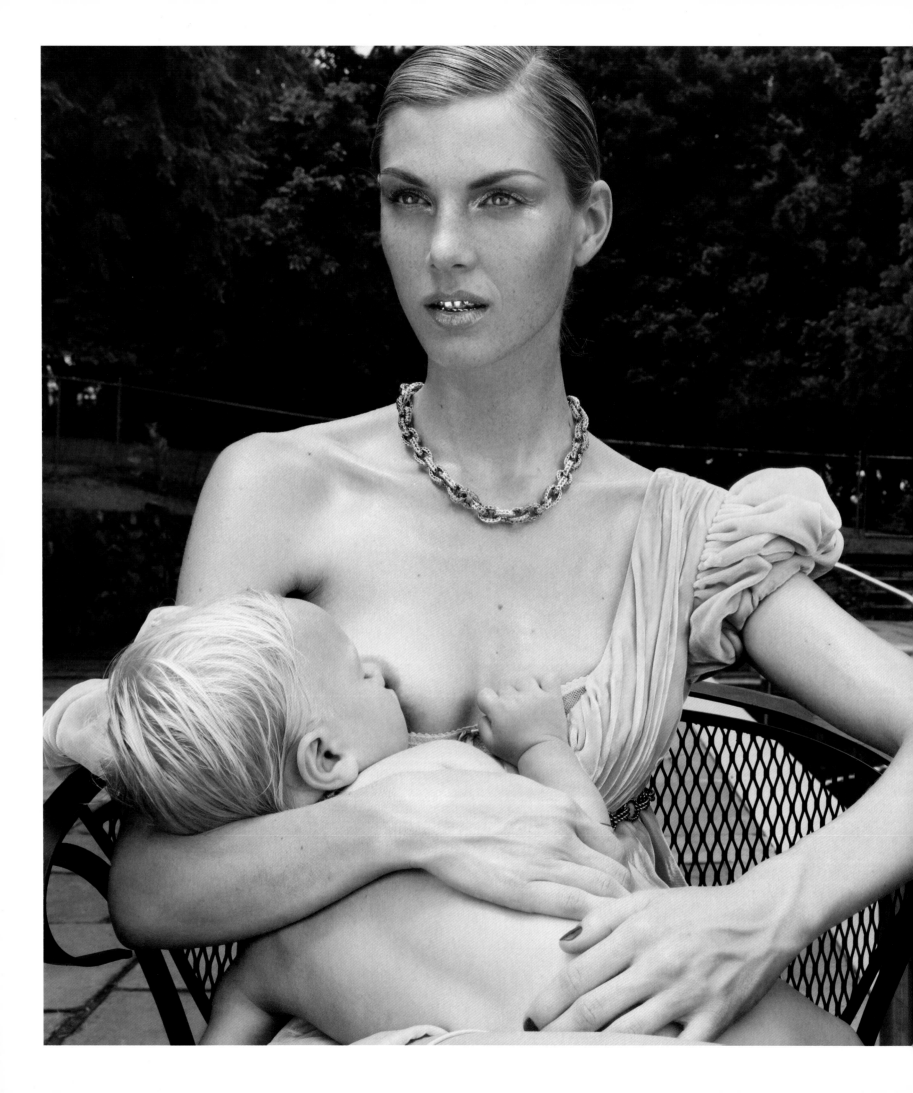

STEVEN KLEIN, *24-Karat Smile*, August 2006.

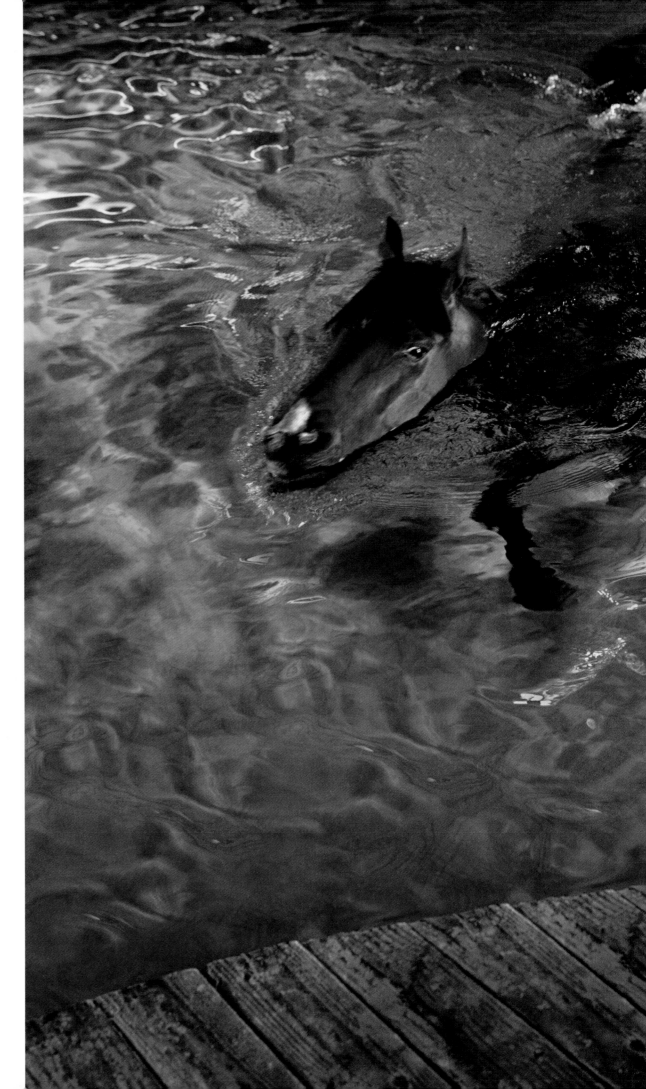

STEVEN KLEIN,
Making a Splash, June 2005 (unpublished).

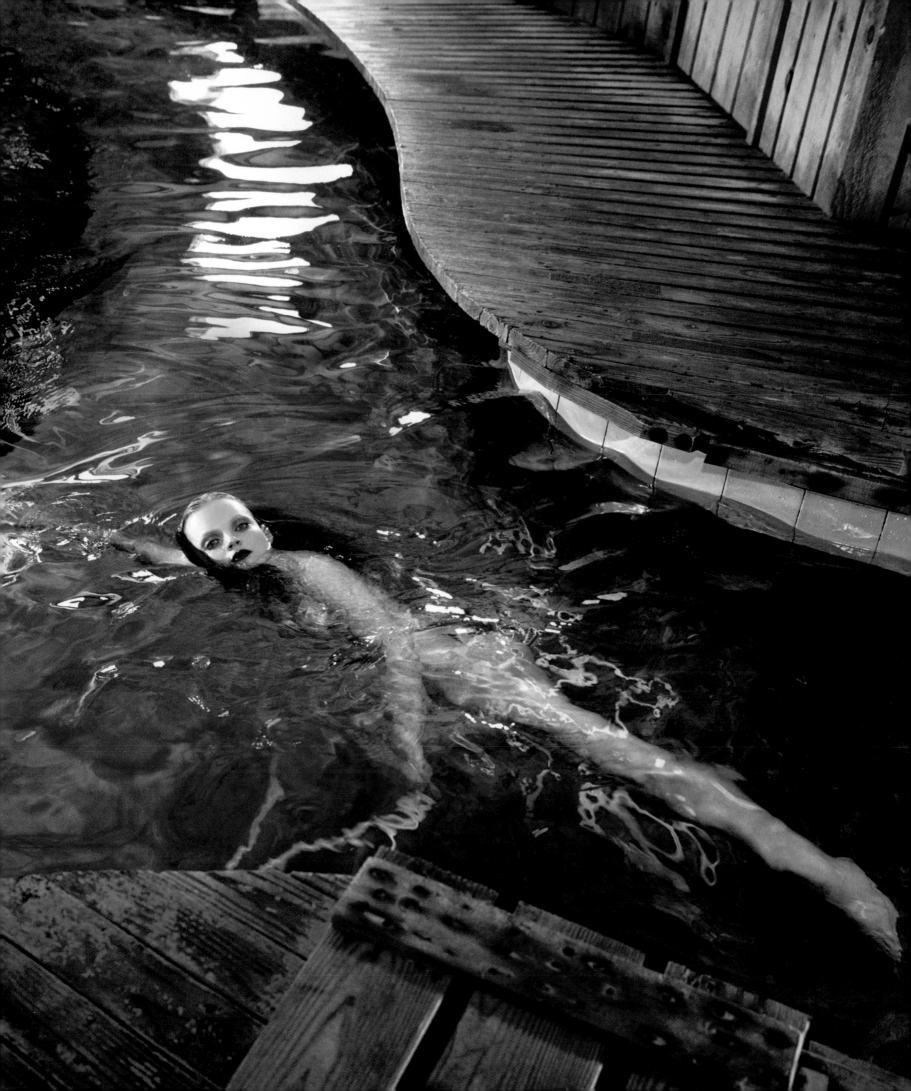

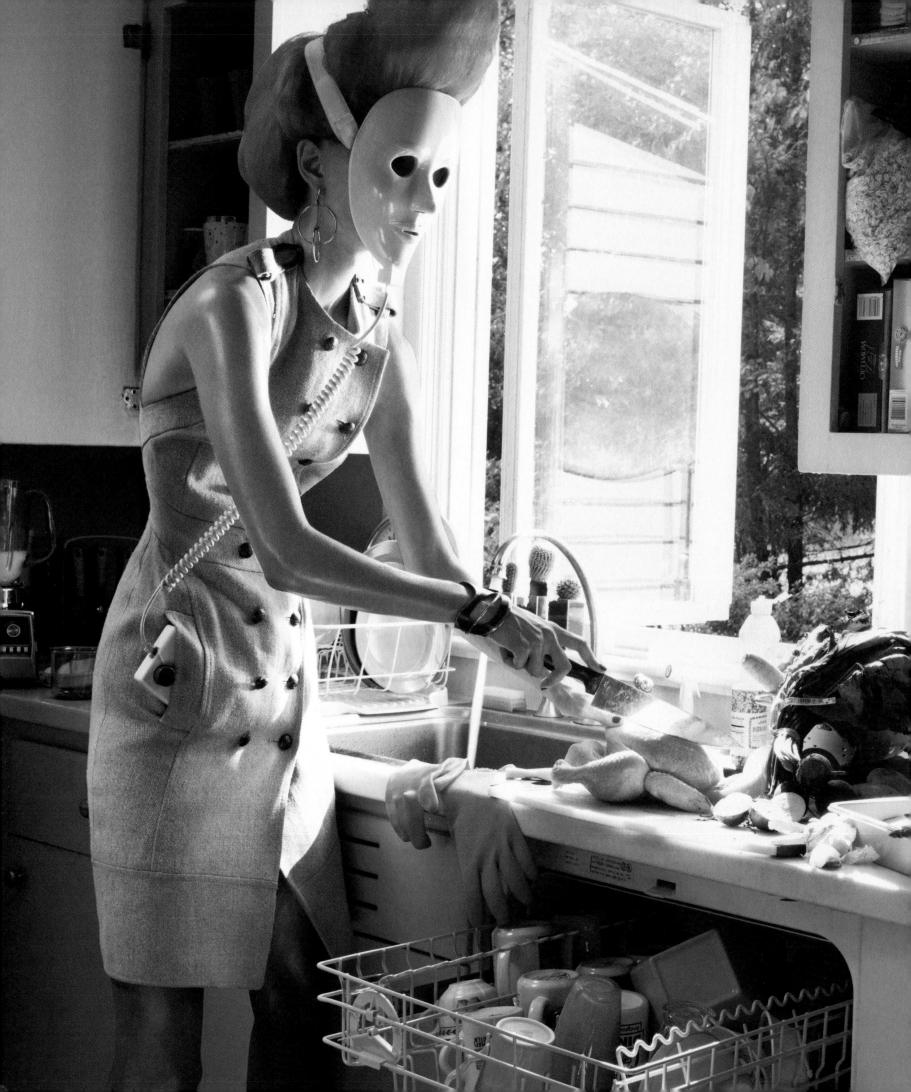

STEVEN KLEIN, *Homework*, December 2007.

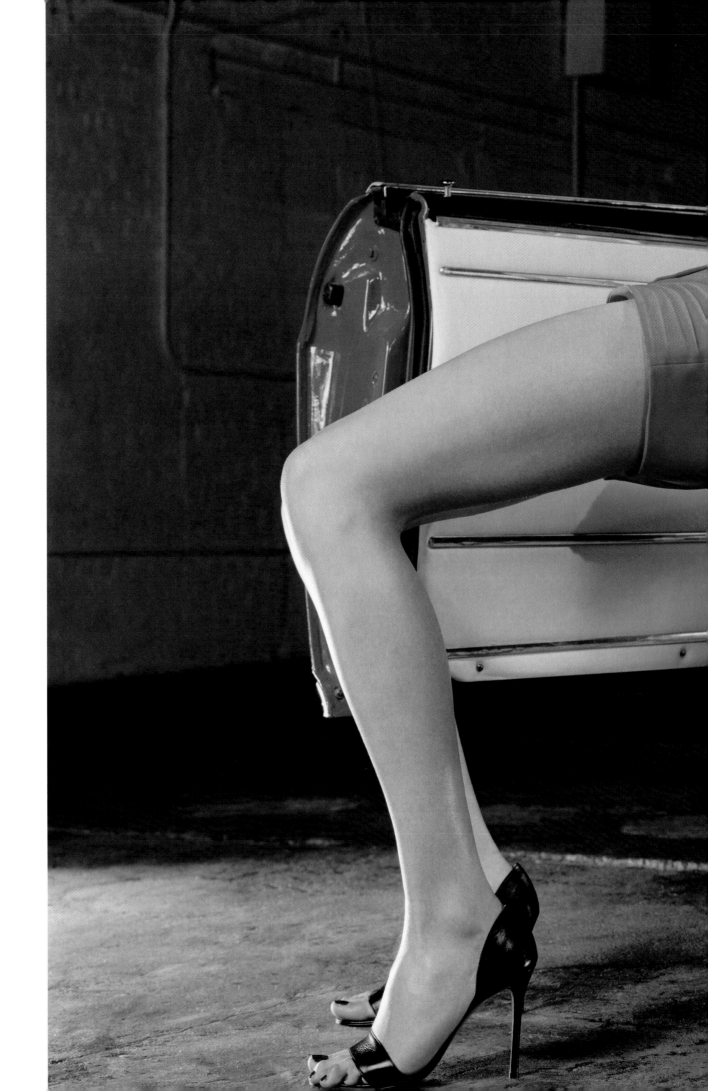

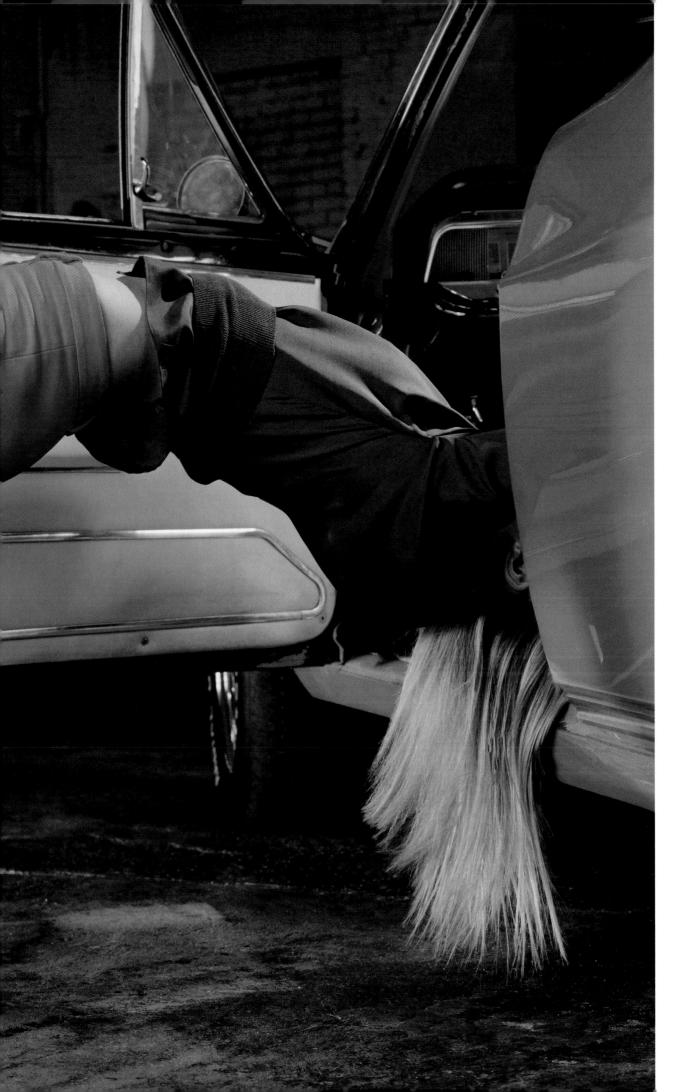

STEVEN KLEIN,
Skirting the Issue, February 2001.

STEVEN KLEIN, *Strength Training*, August 2006.

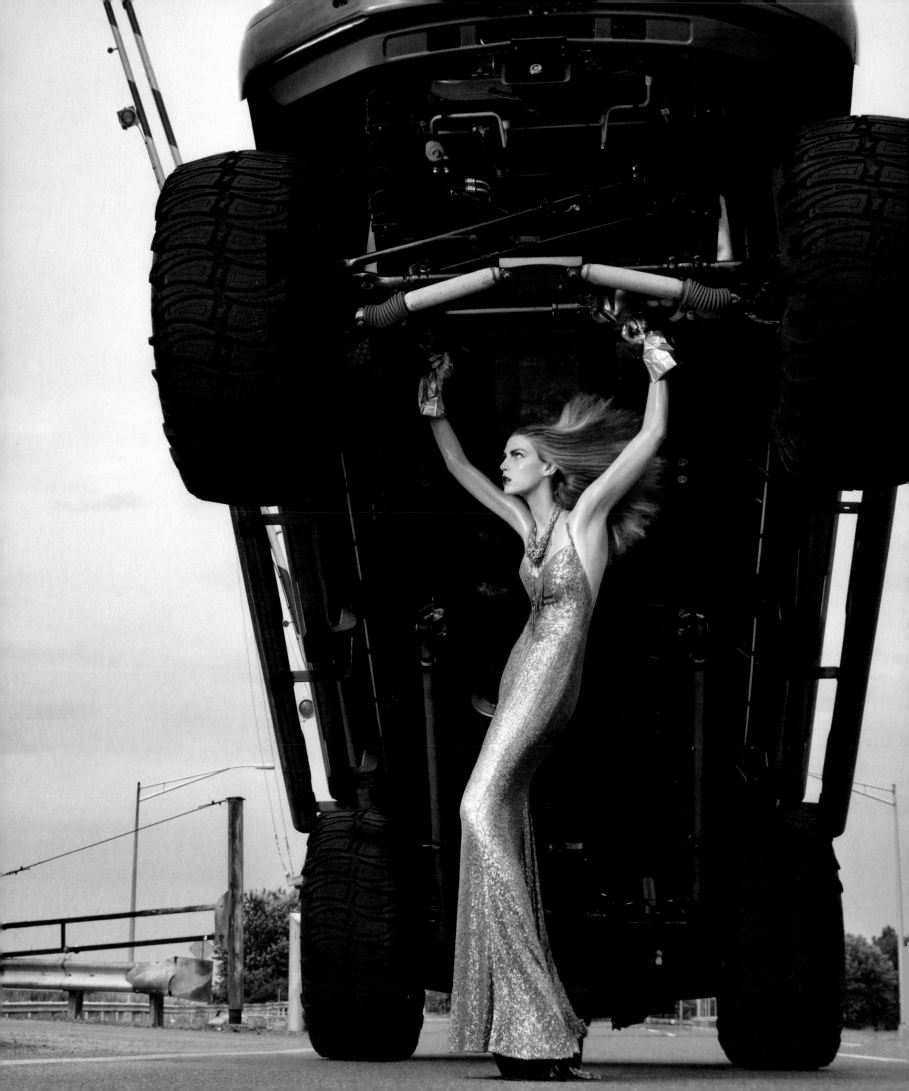

Phyllis Posnick began her career at British *Vogue*. She has worked for Calvin Klein and *Glamour* and joined American *Vogue* in 1987 as Executive Fashion Editor. She collaborated on many of the photographs in this exhibition.

Eva Respini is an assistant curator in the Department of Photography at the Museum of Modern Art, NYC. She curated "Fashioning Fiction in Photography Since 1990" (2004), "New Photography" (2005 and 2007), "Out of Time: A Contemporary View" (2006), and "Into the Sunset: Photography's Image of the American West" (2009).

Ivan Shaw began his career at *Vanity Fair* in 1992. He joined the *Vogue* Art Department in 1994, became Photo Editor in 1996, and has been Photography Director since 1999.

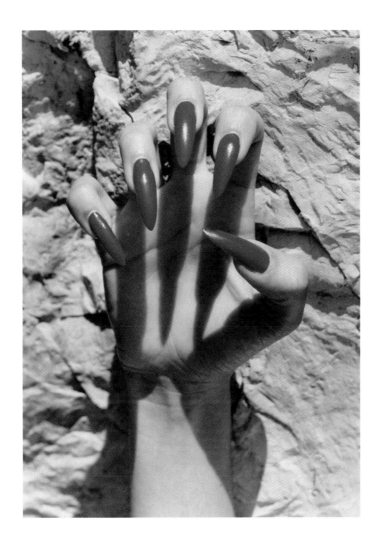

HELMUT NEWTON, *Fingernail Story, Monte Carlo*, 1995 (unpublished),
© 2009 The Helmut Newton Estate/Maconochie Photography.

THANK YOU

To all the photographers for their unique vision.

To Domenico Dolce and Stefano Gabbana for their commitment to photography and their belief in this project.

To Jean Nouvel and Jean Nouvel Design for graciously bringing their phenomenal talent to designing and hanging this exhibition at Palazzo della Ragione.

To the models and teams of hair and makeup people who inspired us and never gave up.

I am grateful to others who helped make this exhibit possible and to all who helped make these photographs. To mention their names is never an adequate expression of one's indebtedness: Ivan Shaw, whose contribution went far beyond his role as producer. Christiane Mack, David Byars, Eve MacSweeney, Eva Respini, Dee Vitale, Roger Krueger, Vasilios Zatse, Norma Stevens, June Newton, Tiggy Maconochie, Michelle Franco, Cassidy Ellis, Sara Moonves, Dodie Kazanjian, Charles Churchward, Desirée Rosario-Moodie, Grace Coddington, Virginia Smith, Candy Pratts Price, Alexandra Kotur, Polly Mellen, Fiona DaRin, Lianna Egelman, Sharif Hamza, Karen Mulligan, Jesse Blatt, Mark McKenna, Allison Brown, Barbara Kean, Susan Sedman, Pamela Vu, Joyce Rubin, Ernie Liberati, Pascal Dangin, Mary Howard, Andrea Stanley, Emily Wardwell, Anthony Petrillose, Jessica Baravarian, Jerry Birenz, Joe Russo, Shawn Waldron, Edward Klaris, Leigh Montville, Christopher Donnellan, and the *Vogue* Fashion Department, Katherine Armenta, Valerie Boster, and Chris Morocco.

I am also grateful for the unforgettable pleasure of knowing and working with Helmut Newton.

2009 marks the thirtieth year since I met Irving Penn and the fifteenth year since we began our work together. He has been a teacher, he has inspired me to go further, dig deeper, be better, and he is my sharpest critic. This exhibit honors that relationship and would not have been possible without his extraordinary photographs.

Finally, to Anna Wintour, editor in chief of American *Vogue,* for her many original ideas and for generously giving me the encouragement to push the limits.

Special thanks to Paul Cohen.

—Phyllis Posnick

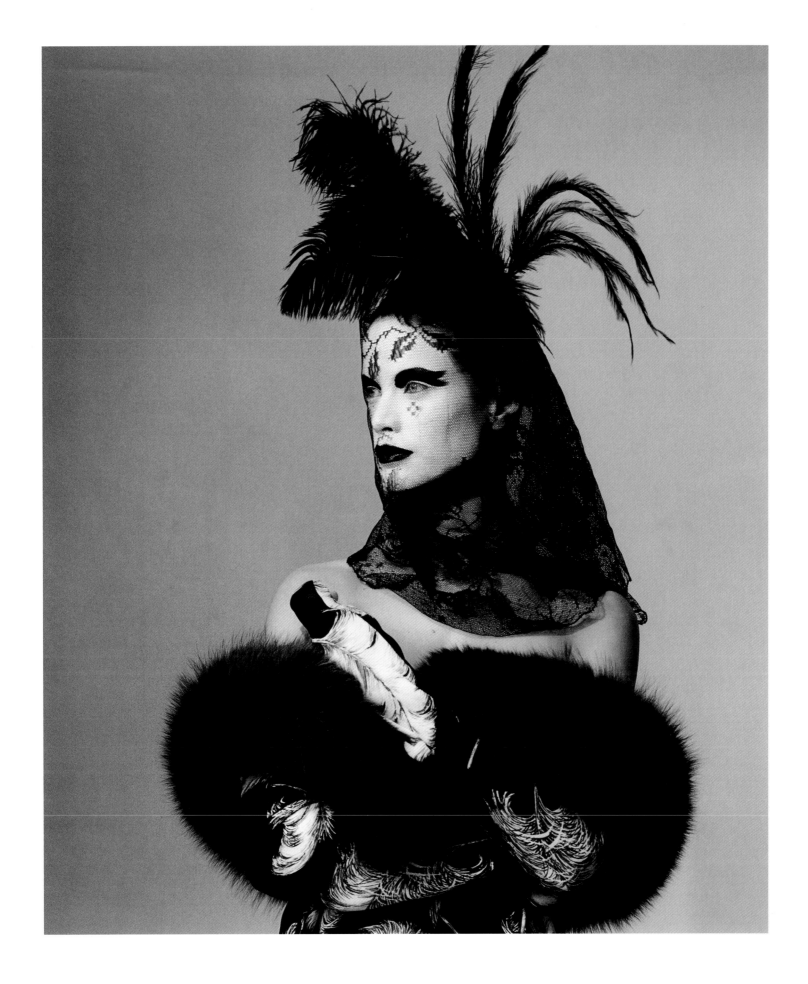

IRVING PENN, *Feather Hat with Veil*, December 1997.

Design by Charles Churchward.

Special thanks to P&G Beauty for their support.

First published in Italy in 2009 by
Skira Editore S.p.A.
Palazzo Casati Stampa
via Torino 61
20123 Milano
Italy
www.skira.net

Printed and bound in Italy. First edition
ISBN: 978-88-572-0032-3 (hardcover English edition)
978-88-572-0213-6 (hardcover)
978-88-572-0150-4 (softcover)

Distributed in North America by Rizzoli International Publications, Inc.,
300 Park Avenue South, New York, NY 10010, USA.
Distributed elsewhere in the world by Thames & Hudson Ltd., 181a High Holborn,
London WC1V 7QX, United Kingdom.